PAINTING THE
Allure of Nature

Susan D. Bourdet

NORTH LIGHT BOOKS
CINCINNATI, OHIO
www.artistsnetwork.com

Dedication

To my mother, who taught me the names of the wildflowers and birds while she taught me to walk. The colors and fragrances of her garden drift through all of my paintings.

And to my dad, whose never-ending patience and support allowed me the time and the freedom to find my way.

SUMMER BANQUET
Black-Capped Chickadees
Watercolor on Arches 300-lb. (640gsm) cold-pressed paper
22" x 30" (56cm x 76cm)
Art from pages 2-3

FALL GOLD
Evening Grosbeaks
Watercolor on Arches 300-lb. (640gsm) cold-pressed paper
14" x 18" (36cm x 46cm)
Art from title page

Acknowledgments

My heartfelt thanks to my husband Jim, who encouraged, supported, washed dishes and listened all through the book writing process. I couldn't have done it without him.

To my daughter Rachael, who understands that quality takes time and generously gave me hers. She also taught me the essential computer skills without laughing.

To my son Dan, who never flinched when asked for his honest opinion and only laughed a little at my computer tangles.

To my sister Rebecca and brother Phil, who believed I could do this even when I didn't.

To Connie, Terry and Arleta, who have written books before and were willing to share their experiences with humor and encouragement.

To my publishers and second family, Wild Wings, who provided the color transparencies for this book. I thank them for always being the supporting wind beneath my timid little wings.

And to Amy and Jamie, my editors, who helped me get the message across.

Painting the Allure of Nature. Copyright © 2001 by Susan Bourdet. Manufactured in China. All rights reserved. No part of this book may be reproduced in any form or by any electronic or mechanical means including information storage and retrieval systems without permission in writing from the publisher, except by a reviewer who may quote brief passages in a review. Published by North Light Books, an imprint of F & W Publications, Inc., 4700 East Galbraith Road, Cincinnati, Ohio, 45236. First Paperback Edition 2003.

07 06 05 04 03 5 4 3 2 1

Library of Congress has catalogued hardcover edition as follows:
Bourdet, Susan D., 1950-
 Painting the allure of nature/ Susan D. Bourdet.— 1st ed.
 p. cm
 Includes index.
 ISBN 1-58180-164-5 (hardcover) ISBN 1-58180-458-X (pbk: alk. paper)
 1. Nature (Aesthetics) 2. Watercolor painting—Technique. I. Title.

ND2237 .B67 2001
571.42'24328—dc21
 00-068694
Edited by Amy J. Wolgemuth and James A. Markle
Designed by Wendy Dunning
Production art by Ben Rucker
Production coordinated by Emily Gross

METRIC CONVERSION CHART		
to convert	to	multiply by
Inches	Centimeters	2.54
Centimeters	Inches	0.4
Feet	Centimeters	30.5
Centimeters	Feet	0.03
Yards	Meters	0.9
Meters	Yards	1.1
Sq. Inches	Sq. Centimeters	6.45
Sq. Centimeters	Sq. Inches	0.16
Sq. Feet	Sq. Meters	0.09
Sq. Meters	Sq. Feet	10.8
Sq. Yards	Sq. Meters	0.8
Sq. Meters	Sq. Yards	1.2
Pounds	Kilograms	0.45
Kilograms	Pounds	2.2
Ounces	Grams	28.4
Grams	Ounces	0.04

About the Author

"Ultimately, all artists hope to achieve an artistic style that is unique and recognizable. Susan Bourdet has achieved both of these elusive qualities. Through years of dedication and her passion for art and natural subjects, she has developed a painting style that elegantly captures the beauty of nature with the demanding medium of watercolor.

I have know Susan for many years. I enjoy her friendship and admire her art. In her book readers will find inspiration, and discover the allure of nature through Susan's art."

—Terry Isaac

Susan Bourdet grew up in western Montana, learning early to love nature. Her luminous watercolors combine realistically detailed birds and animals with soft, impressionistic backgrounds, a technique that has evolved through her twenty years of painting. She discovered watercolor at age twelve, being captivated by a local artist's demonstration. She majored in art and biology, her two great loves, while in college at Montana State University. After graduation in 1972, she struggled to find a way to combine her two interests, working as an artist for a ceramics company and later as a pharmacy technician. Susan's career as a professional artist didn't really begin until 1980, when she and her husband moved to Oregon. While raising her children, she joined a support group of nature artists and, with their help, began to show her work in local galleries. She lives with her husband Jim and children Rachael and Dan on several acres of wild woodland, which provide settings and subjects for her paintings.

In 1989, her paintings were discovered in a small Portland gallery by Wild Wings. She now has over forty limited editions and her work is featured in a yearly songbird calendar published by Bookmark. She enjoys sharing her unique methods and insights ith other artists and nature lovers in watercolor workshops and seminars.

To learn more about Susan Bourdet's artwork or to purchase her limited edition prints and original paintings, please contact Wild Wings at 1-800-445-4833. Or visit their web site at www.wildwings.com. Some of her artwork is not available in print form.

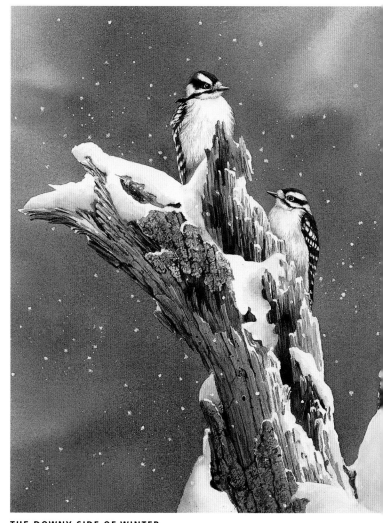

THE DOWNY SIDE OF WINTER
Downy Woodpeckers
Watercolor on Arches 300-lb. (640gsm) cold-pressed paper
14" x 18" (36cm x 46cm)

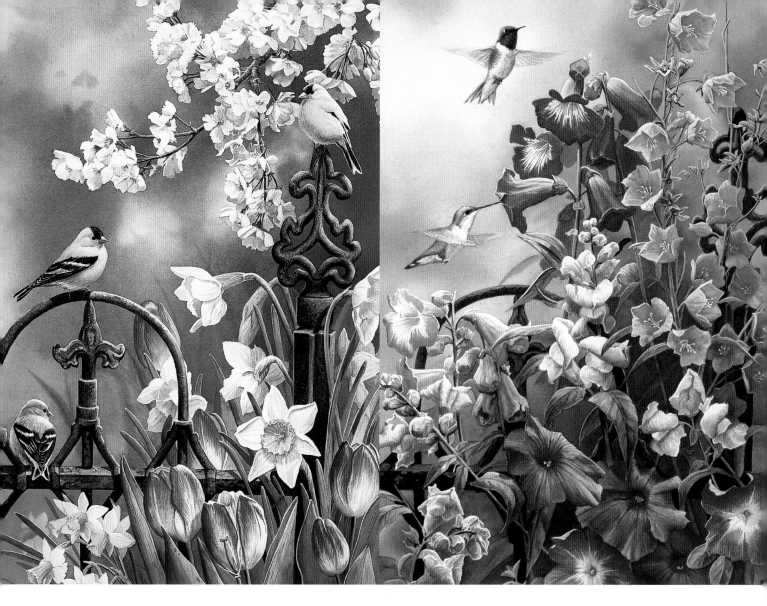

Table of Contents

Learn the tools and preparations you need to create watercolor paintings containing birds and flowers. You will also gain an understanding of the basic properties of watercolor and how to choose a palette. Learn how to mix colors and how different applications create different effects.

Good reference materials make great paintings. Learn about the equipment and resources you need and how to find and use them to compose your paintings.

Take a detailed, step-by-step look at the basic methods used most often to paint background scenes from nature.

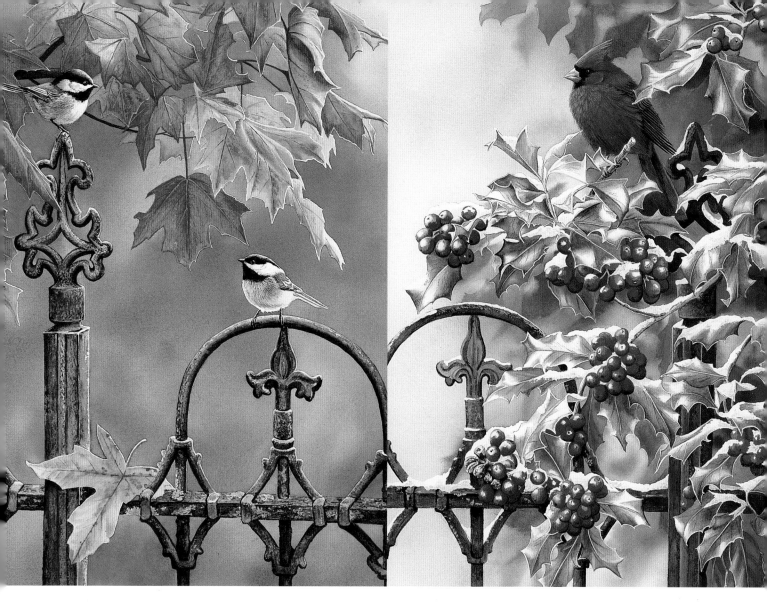

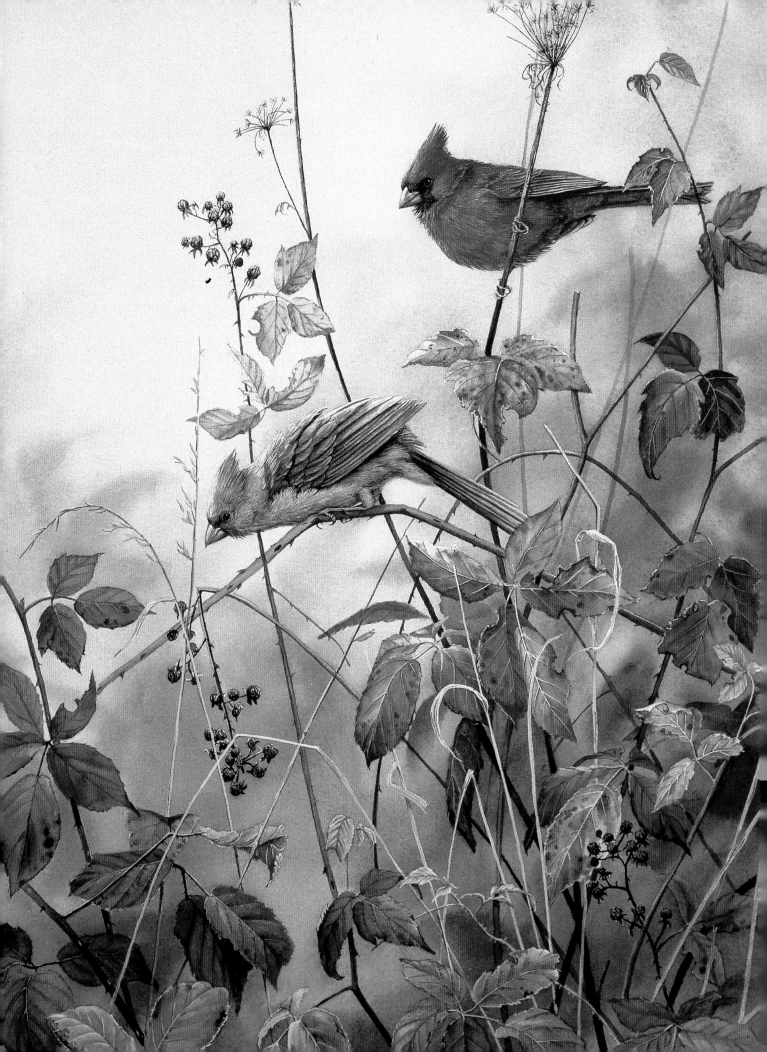

Introduction

As I watched a watercolor demonstration for the first time, I was sure that the beautiful flow of vibrant color was as effortless as it appeared to be. The watercolor seemed to paint itself as the pigments blended on the paper, creating a lovely free-form illusion. Later, after many discarded attempts, I decided that the painter I'd watched was a magician. His sleight-of-hand happened so fast that I could barely discern the well-practiced technical mastery beneath the seamless performance. I suppose it is the same with any art—well done, it looks easy. So I won't begin by telling you that watercolor is easy. At the same time, it is not a magic act either.

The experience of learning to paint is a journey—in order to get there happily, you have to enjoy the trip, realizing that you are not going to arrive overnight. When I began painting, I remember how anxious I was to get my brush into the pigment, to get those first juicy strokes on the paper. I wanted to capture some of that magic for my own! My early attempts resulted in some soggy, muddy disasters. While this book may not be able to prevent you from making your share of mistakes, I think everyone who paints eventually realizes that they have learned as much, maybe more, from the paintings they threw away as they did from their successes. So the main thing I would say to anyone just starting the journey as a painter, is to wade in without fear. My first teacher told me that before I mastered the medium, I'd throw away a hundred paintings. So, if you accept goof-ups as part of the process, you won't be discouraged when they happen.

In writing this book, I have kept no secrets. I've described for you, start to finish, how I execute a painting. If you are a beginner, remember that success is really just a matter of practicing the basic wash techniques until you attain a real understanding of the interaction between paint, pigment and paper. I can't tell you this part. You have to acquire this understanding hands-on. I urge you to spend plenty of time with this part of the process, painting lots of washes in various color combinations on small pieces of watercolor paper; then graduate to larger sheets. When you can predict how paint behaves on sheets of varying wetness, you will have the understanding needed for every single painting you do.

In the first chapter, we'll study the tools—the paint, paper, brushes and equipment I find works best for me. You are free to choose your own materials. You'll find that some materials appear in my chapters over and over again, simply because they work so well for me that I'm confident in passing them along to you. In the second chapter, our emphasis is on the idea—where to find it, how to record it and how to put it to work in a painting. You'll learn to work out a composition so that your entire painting will support the main idea. In chapters three, four five and six we'll begin to build your technical skills until you have a good basic arsenal with which to tackle the projects in the final chapter.

My paintings reflect two things—the emotional response I feel to nature in all her colors, shapes and seasons, and the technical skills I've developed through years of painting. My goal is not to turn you into an artist whose work looks like a reflection of mine—this is about you, your own choice of subject matter and expression. You'll find that the most exciting and satisfying part of the whole process is coming up with your own unique concept and then using the methods you've learned to carry out that idea. The sample projects in the book are designed to help you learn from start to finish how to transform ideas into paintings. By coming up with your own ideas and expressing your own feelings and visions, you will arrive at your own alluring version of watercolor magic!

FALL BRILLIANCE
Northern Cardinals
Watercolor on Arches 300-lb. (640gsm)
cold-pressed paper
21" x 15" (53cm x 38cm)

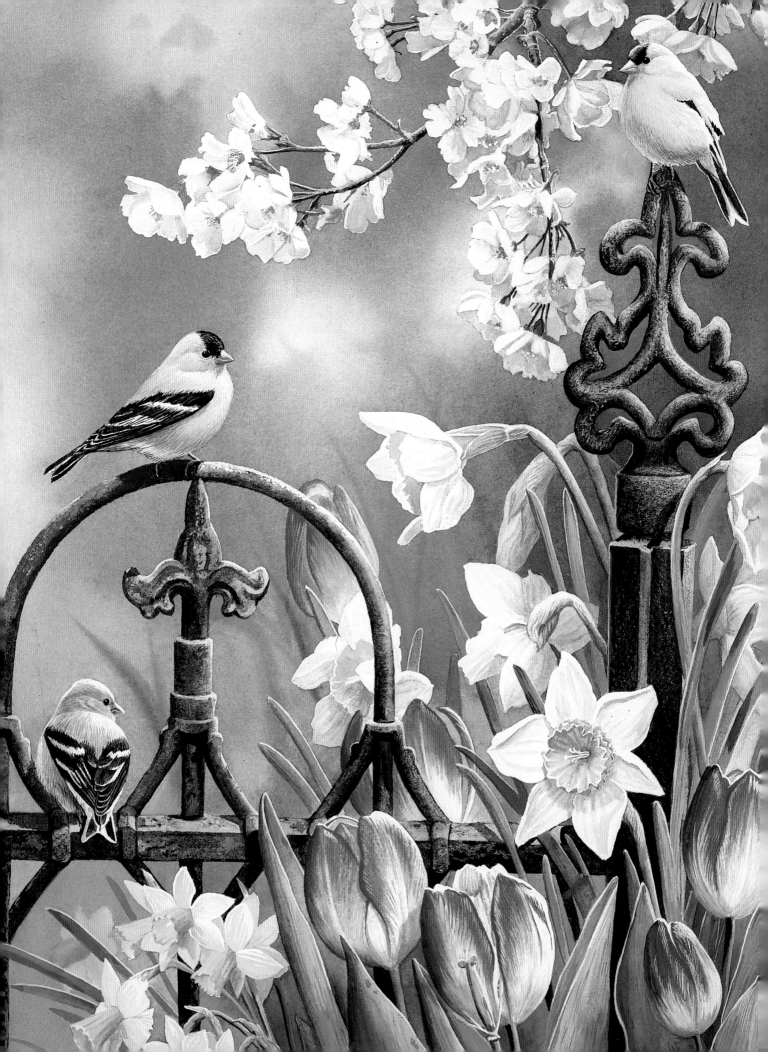

Materials, Preparations & Choosing Pigments

*M*ost aspiring artists had their first encounter with watercolor in grade school. The usual experience was to be handed a sheet of white construction paper, a small pan set of watercolors and a stubby brush. While we started with high hopes, most of us were spattered, frustrated and unhappy with this first attempt, having been given all the wrong materials and few guidelines. I can remember the horse I painted when I was twelve. The horse turned out fairly well, only to be overrun by a very wet green field totally out of control.

Once I recovered from the wet field experience, my parents enrolled me in an adult watercolor class to give me a creative summer activity. It wasn't that I was so advanced an artist at twelve, but simply that no children's classes were offered. The instructor loved wet-into-wet and, with his first vibrant, free-flowing demonstration, I was captivated. It seemed to me that his paintings were created through a mysterious, spiritual process. I felt that if I could equal his passion, I would be able to perform the same magic. While the medium was still difficult to master, my whole experience was positive in the adult class because I was working with the right materials and some skilled guidance. My first painting, to my great embarrassment, still hangs on the wall in my parents' home. While obviously the work of a child, it shows how much I learned and what a big difference the right tools can make.

VICTORIAN SEASONS—SPRING
American Goldfinches
Watercolor on Arches 300-lb. (640gsm) cold-pressed paper
21" x 15" (53cm x 38cm)

Paper

The most important secret to painting a good watercolor is using the right paper. So many people try to avoid spending money on good paper and begin with small water-color pads or blocks that are, frankly, a waste of your money. Even if you cut corners on some of your other equipment, buy good paper—you'll be glad you did! I use Arches paper, and I almost always paint on the 300-lb. (640gsm) weight. Equally good is the 140-lb. (300gsm) but it will always need to be stretched.

Watercolor paper comes in a variety of surfaces: rough, cold-pressed and hot-pressed. I use the smoother side of the cold-pressed paper, because the slight bumps and dips in the surface help to hold the pigment, while it is still smooth enough for lots of detail. The smoother side has the Arches watermark, as opposed to the other side, which has no watermark and is just a bit rougher. To conserve paper, you can use the smooth side of each sheet for your serious efforts and then use the back for practicing techniques and textures.

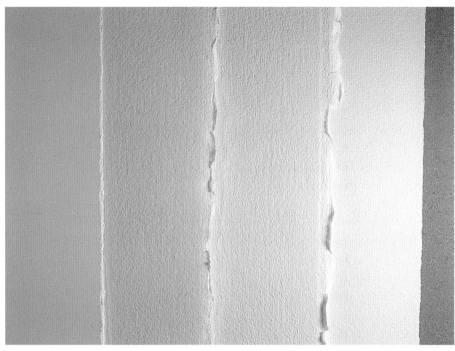

Paper Comes in Various Weights and Finishes
From left to right, Arches 140-lb. (300gsm) cold-pressed, Arches 300-lb. (640gsm) cold-pressed rough side, Arches 300-lb. (640gsm) cold-pressed smoother side, Arches 300-lb. (640gsm) hot-pressed.

Tip
Flattening Warped Paper
I confess that I sometimes skip the process of stretching the 300-lb. (640gsm) paper for small projects and simply weigh the finished painting down on a flat surface for a few days to flatten it. I mist the back of the painting lightly, then place it face up on a dry tea towel. A clean piece of glass or plexiglass works well as a weight.

Stretching Paper

Stretching your paper is a good idea and many artists advocate always doing this, no matter what weight paper you use. Stretching keeps the paper perfectly flat and tight, eliminating all those buckles and waves that are impossible to work with. If you work with lots of water or are wetting the painting repeatedly, don't skip stretching your paper even when using the 300-lb. (640gsm) paper.

The best board to stretch your paper on is Gator board, a lightweight, washable, unwarpable, reusable board available at most art supply stores or through mail order catalogs. Use the tub to thoroughly wet the paper. Staple the edges to the board, setting the staples in ⅜"–½" (10mm–12mm). After the wet sheen has gone off the sheet, tape the edges down with packing tape to keep the staples from pulling out. Allow it to dry completely flat.

MATERIALS LIST	Arches 140-lb. (300gsm) or 300-lb. (640gsm) cold-pressed paper, 22" x 30" (56cm x 76cm)
	Bathtub or large laundry tub
	Gator board
	Gummed packaging tape (the old-fashioned type that you moisten)
	Heavy-duty stapler that opens up

1 Wet the paper thoroughly in the bathtub or laundry tub. Make sure the tub is clean, without any oil or soap residue. Allow the excess water to run off as you remove the paper. Place the paper, watermark side up, on your heavy-duty Gator board.

2 Staple the edges of the wet paper to the Gator board, placing the staples just inside the deckle edge, about 3" (8cm) apart.

3 Air-dry until the shine leaves the paper, then tape over the edges with gummed packaging tape to reinforce the staples. Blot tape with a paper towel to stick down firmly. Allow the stretched paper to air-dry, keeping the board flat until completely dry. Paint with the paper still stapled to the board—it will stretch tight as it dries.

Brushes and Palette

Brushes

A brush is a wonderful tool, working as an extension of your hand and mind. I use a variety of sizes and brands, some are fine Kolinsky sables and others are synthetic. Genuine sable brushes are very expensive but have the advantage of holding more pigment. They last a very long time with proper care. I find that the Robert Simmons White Sable line is the best imitation sable brush, performing quite well for a less serious investment. Whether you opt for sable or synthetic, always buy a good, reputable brand—there are some poor quality, less expensive brushes that look good but perform badly. My favorites are shown below.

Palette

Use a large palette with deep wells and a large mixing area. I like to squeeze an entire tube of paint into each well and let them dry in there. I re-wet the colors each day before I start to paint, using a spray bottle. When the wells become contaminated with other colors, I rinse the palette in running water, letting the water gently flush each well to keep the colors clean. This way, you waste very little paint and the colors stay clean and fresh.

One of the most vital lessons in painting is to keep your palette clean. Take the time to wash the mixing surface after each step in the painting process—a dirty palette means muddy colors. When working on large wet-into-wet washes where I need to mix large puddles of color, I mix the colors on a porcelain butcher's tray—then I can save the background color mixes in case I need to make a correction.

Tip
Hake Brushes
When purchasing a hake brush, be sure to buy the stitched kind rather than the kind with a metal ferrule. These brushes shed hairs at first and feel sort of clumpy. The bristles gradually become tapered by abrasion on the watercolor paper, so the brush performs better with age. Mine is ten years old and is my favorite brush for applying wet-into-wet washes.

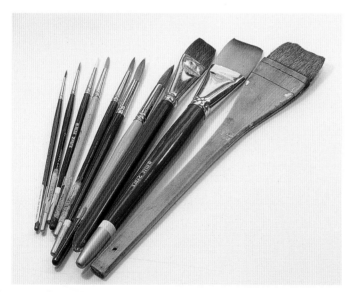

Some of My Favorite Brushes
From left to right, nos. 1, 2, 4, 6, 8, 10 and 12 round sables or white sables, 1-inch (25mm) flat sable, 1½-inch (38mm) flat white sable and 2-inch (51mm) Chinese hake.

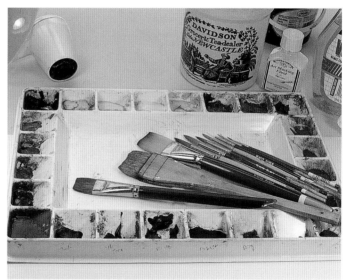

Palette and Brushes
A palette with deep wells will hold a lot of paint, freeing you to focus on painting rather than gathering more colors for your palette.

Other Supplies

In addition to the basics of paper, brushes and palette, you will need other supplies before you begin painting.

Masking Fluid

I use masking fluid in nearly every painting because it allows me to create a free-flowing wet-into-wet wash without struggling to paint around complicated shapes. I prefer using yellow-tinted Winsor & Newton Art Masking Fluid, which is readily available and easy to use. Always check it for freshness—it should have a sharp ammonia smell. Masking fluid is a lot like rubber cement when it gets in your brushes. Always use imitation sables rather than true sable, because it tends to gum up on those genuine sable hairs, ruining the brush. I like to save my slightly frayed older brushes for use in masking fluid. It helps to work a little bar soap into the bristles before you dip the brush in the fluid. Rinse the brush frequently during use and keep it wet—if masking fluid is allowed to dry on the brush, you'll have to throw it away. Cleaning with a little ammonia will help the brush last longer.

Spray Bottle

When you re-wet a painted area, you'll need to use a spray bottle rather than a brush because the brush will tend to pick up the pigment. Good sprayers are hard to find—most of them deliver a hard, focused blast that can mar the painted surface. I've had the best luck recycling my old glass cleaner bottles—the gentle spray is just right—not too hard, and not too drippy.

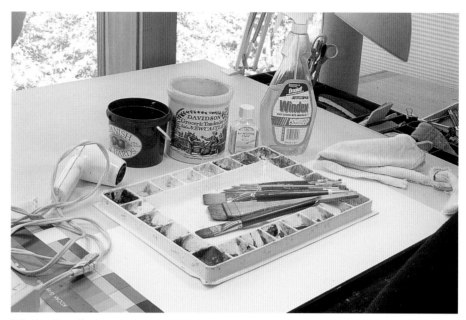

Painting Supplies
Here are just some of the supplies you may find useful when painting. Feel free to add these to your list of favorite items to use.

Water Containers

It's important to have good-sized water containers. I always fill two so that I have one to rinse my brush in and another to use when I wet the paper or mix colors. Frequent water changes, especially after doing a large, dark wash, will also help to keep the colors in your artwork clean and unmuddied.

Miscellaneous Supplies

Additional tools you may find useful are:
- 2B pencils
- Hair dryer
- Kneaded eraser
- Old bath towels
- Old toothbrushes, hard and soft
- Palette knife
- Paper towels and clean soft rags
- Pencil sharpener
- Table salt

Painting Area

The way you set up your painting area is as important as the tools you use. You'll need some color-corrected lights, a good, comfortable chair and a large flat or slightly tilted surface. Good natural light is a real asset but bright, full-spectrum artificial light will do. Full-spectrum light bulbs and fluorescent tubes are available in art supply shops and building supply stores. Place your palette and water containers conveniently on your dominant side, along with a soft, absorbent rag and your favorite brushes. Attach your hair dryer to an extension cord so you can grab it quickly and move it freely over the painting surface.

The Basic Properties of Color

Colors have three basic properties: hue, value and intensity. *Hue* is the property we define as color—in other words, its name, like red. When we talk about the *value* of a color, we mean its lightness or darkness, all the way from nearly white to nearly black. The *intensity* of a color is its brightness or saturation. To understand these properties, look how the six colors are organized differently according to each characteristic.

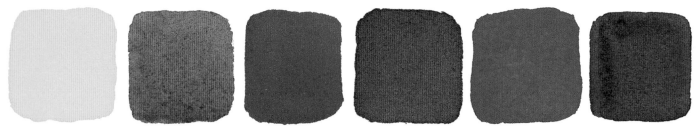

Hue
Hue can best be defined as the name of the color. The colors above (from left to right) are: Hansa Yellow Light, Quinacridone Gold, Quinacridone Red, Burnt Sienna, Oxide of Chromium and Prussian Blue.

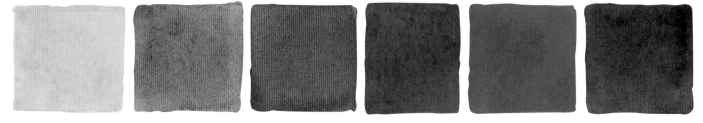

Value
If you squint until you no longer see the hue you'll be able to see the color values. The colors listed from the lightest value to the darkest (from left to right) are: Hansa Yellow Light, Quinacridone Gold, Burnt Sienna, Quinacridone Red, Oxide of Chromium and Prussian Blue.

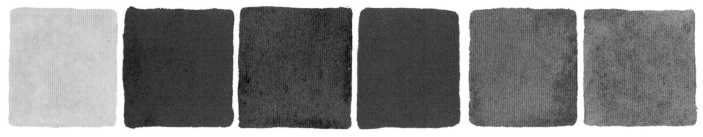

Intensity
The most vivid colors are of higher intensity—colors ranked from brightest to dullest are not in the same order as those ranked from lightest to darkest. They are (from left to right): Hansa Yellow Light, Quinacridone Red, Prussian Blue, Oxide of Chromium, Burnt Sienna and Quinacridone Gold.

Tints, Tones and Shades

As you mix colors, you will also explore the use of *tints*, which are colors mixed with white; *tones*, which are colors mixed with gray and *shades*, which are colors mixed with black. In watercolor we use tones, but since we don't use white paint very often, our version of a tint is diluting the color to allow the white of the paper to visually mix with the hue. Since we don't actually use black, we can create cool shades by mixing with Payne's Gray, which is really a dark indigo. Another way to create shades is to mix two intense complements to make a dark neutral, and then add that to the color.

Transparency

Watercolor pigments can be classified according to their degree of transparency. Some colors are very transparent, even when fully saturated. Other colors can be nearly opaque, so that the white paper can't be seen through the color layer.

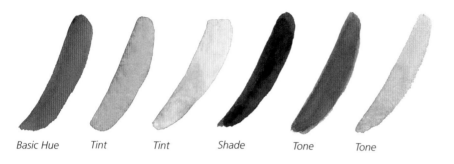

Basic Hue Tint Tint Shade Tone Tone

Altering Colors
You can alter the appearance of a basic hue like Quinacridone Pink by adding water to create tints, Payne's Gray to create shades and neutral grays to create tones.

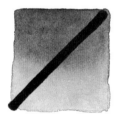 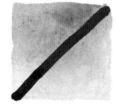 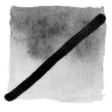

Transparent Colors
The Hooker's Green Dark on the left is a transparent color. The black line clearly shows through when the pigment is painted over it. The Oxide of Chromium on the right is opaque. The pigment covers the black line when painted over it.

Sedimentary Colors
Transparent and partially transparent colors can also be sedimentary, which means that they are composed of fine particles that settle out when diluted, creating a slight texture. Notice how both the Manganese Blue Hue on the right and the Raw Sienna on the left break down into smaller particles.

Staining Colors
Many colors will stain the paper to some degree. If you wish to lift away some pigment to create a highlight, you must take into account that the color has actually penetrated the paper. Some staining quality is good when you are glazing pigments because these colors don't lift when others are glazed over them. A few colors, like the Phthalo Greens and Blues, will stain the paper so dramatically that they are impossible to lift or rinse off. Ultramarine Blue, a staining color (on the left), cannot be lifted while Naples Yellow, a non-staining color (on the right) can be lifted.

Choosing Your Palette

For the visually oriented, color shopping is a little bit like being let loose in a candy store—this is temptation beyond belief. Over the years I have purchased and tried a lot of different colors. For many years I worked with only six colors, preferring to mix most hues. In recent years some real advances have taken place in pigment science, allowing manufacturers to offer an amazing array of very intense transparent colors that are also very permanent. I've added some of these to my palette because they are more vivid than the colors I used to mix. You should try new colors and experiment, but if you are just starting to build your palette, you'll want to choose carefully, purchasing some good basics and then adding in a few flamboyant hues that please your color sense. It works well to choose a basic palette that incorporates the colors of your favorite subjects.

Tip
Painting Feather Details With Gouache

For adding feather details, I use Winsor & Newton Permanent White Designer's Gouache. I avoid using white in washes and color mixtures, but find that I can paint more realistic feather textures if I add very fine lines of gouache. I use a small separate palette for gouache so that the watercolor pigments don't become contaminated with white and lose their transparency. In many cases the out-of-the-tube white is too white, so I mix it with a little watercolor to make a pale tint. Remember that white pigment mixed with any watercolor makes the pigment opaque, and opaque colors dry darker than they appear when wet—the opposite of pure watercolor. You'll have to lighten your feather details to account for this.

THE PALETTE

Colors I Frequently Use

Burnt Sienna (Winsor & Newton)—*transparent, sedimentary, dries lighter*

Cobalt Blue—*semitransparent, sedimentary*

Green Gold—*semitransparent, very little staining*

Hansa Yellow Deep—*semitransparent*

Hansa Yellow Light—*semitransparent*

Hooker's Green Dark (Winsor & Newton)—*transparent*

Manganese Blue Hue—*transparent, very sedimentary, quite staining*

Naples Yellow—*opaque, non-staining*

Oxide of Chromium (Winsor & Newton)—*rather opaque, dries darker*

Payne's Gray (Winsor & Newton)—*a semi-transparent indigo, dries lighter*

Prussian Blue—*transparent, quite staining, dries lighter*

Quinacridone Gold—*transparent*

Quinacridone Pink—*transparent, dries a little lighter*

Quinacridone Red—*transparent, staining, dries a little lighter*

Colors I Occasionally Use

Cerulean Blue (Winsor & Newton)—*semiopaque, sedimentary, non-staining*

Organic Vermilion—*semitransparent, sedimentary*

Quinacridone Sienna—*transparent*

Raw Sienna—*semitransparent, sedimentary, dries lighter*

Ultramarine Blue—*semiopaque, sedimentary, staining, dries lighter*

Ultramarine Turquoise—*semitransparent, somewhat staining*

Ultramarine Violet—*transparent*

Winsor Yellow—*semitransparent*

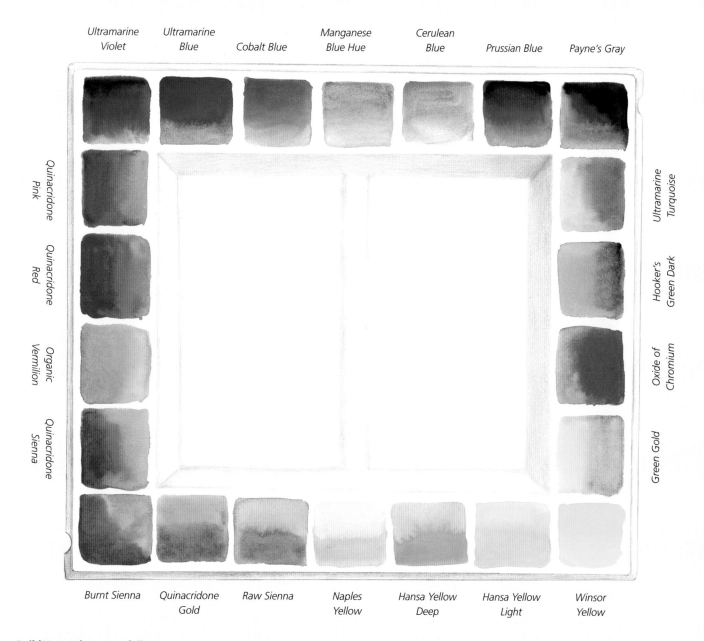

Ultramarine Violet · Ultramarine Blue · Cobalt Blue · Manganese Blue Hue · Cerulean Blue · Prussian Blue · Payne's Gray

Quinacridone Pink · Quinacridone Red · Organic Vermilion · Quinacridone Sienna

Ultramarine Turquoise · Hooker's Green Dark · Oxide of Chromium · Green Gold

Burnt Sienna · Quinacridone Gold · Raw Sienna · Naples Yellow · Hansa Yellow Deep · Hansa Yellow Light · Winsor Yellow

Build Your Palette Carefully

My color palette is made up of Daniel Smith and Winsor & Newton watercolors. I trust these brands because I know both companies have done extensive research to ensure the quality, consistency and permanence of their pigments. Most of these pigments stain the paper but can be lifted partially. Most of them fall into the transparent and semitransparent categories because these pigments are more versatile and workable than opaque colors. The colors I use in the greater percentage of my paintings are basic earth colors for nature paintings, while the others are used to fill out the palette for floral compositions and birds.

Mixing Colors

Having wonderful colors to squeeze right out of the tube doesn't absolve you from the mixing process. For one thing, mixing colors is one of the best methods of putting your own individual stamp on your work. It also allows you a much more versatile color range. You need this range because local color (the actual hue of a flower, for example), is modified by light so that even the simplest object is made up of tones, shades and reflections.

You must be aware that watercolors lighten in value as they dry. This is the opposite of opaque water-based media, which dry darker. Each color has its own unique drying characteristics. Payne's Gray, for example, lightens more as it dries than Hooker's Green Dark. When combining the two, this means that the green will overpower the gray unless you begin by mixing the gray darker. Remember that when you're working with watercolor on wet paper, not only are you diluting it with the water in the paper, but it will also naturally lose value as it dries. Wet washes, therefore, need to look darker than you want them to be so that the dry result will be the right value.

In watercolor, there are three ways to mix color: pre-mixing on the palette, mixing on the paper and glazing. Consult the three examples on this page to learn these techniques.

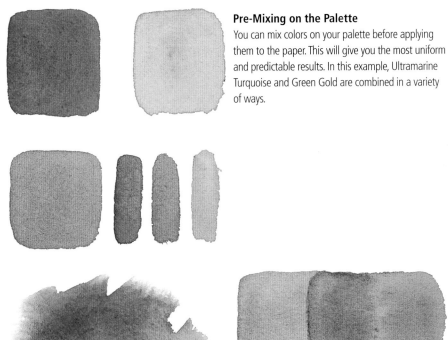

Pre-Mixing on the Palette
You can mix colors on your palette before applying them to the paper. This will give you the most uniform and predictable results. In this example, Ultramarine Turquoise and Green Gold are combined in a variety of ways.

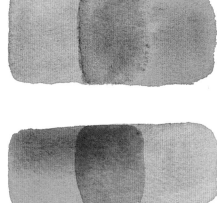

Mixing on the Paper
You can apply the colors to wet paper and let them mix by running together, or you can apply two juicy swatches of color next to each other on dry paper and let them blend. This takes more practice, but allows you to combine colors that would look muddy if you pre-mixed them. When Ultramarine Turquoise and Green Gold are applied to the wet paper they bleed together creating a gradual color transition. This method is wonderful for backgrounds.

Glazing
You can take advantage of the transparency of the pigments by using them like overlays of glass, glazing one layer of color over another. This painting method is ideal for objects like flowers, where you need to gradually build up the colors and values to define the form. Notice the difference between glazing Ultramarine Turquoise over Green Gold (top) compared to a glaze of Green Gold over Ultramarine Turquoise (bottom).

Mixing Rich Darks

Sometimes beginning watercolorists complain that their paintings look washed out, lacking in brilliance. Here an understanding of your pigments is essential to success. In order to avoid that pallid look, you will need to be able to mix rich, luminous darks. Remembering that watercolors dry lighter, don't be afraid of using saturated color. In general, you'll have the best success if you choose colors that, at high saturation, are on the dark-end of the value scale like Payne's Gray, Quinacridone Violet, Hooker's Green Dark and Prussian Blue. The best colors for luminous, rich darks are the transparent and semitransparent colors. An exception to this is the combination of Oxide of Chromium (an opaque) with Payne's Gray. I frequently use this mixture for muted background foliage. Avoid premixing complements or near-complements, as the results can be dull. In these examples, high-intensity transparent and semitransparent colors were mixed first on the palette and then on wet paper.

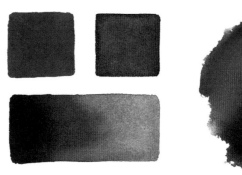

Quinacridone Pink and Payne's Gray
The rectangle shows Quinacridone Pink combined with Payne's Gray mixed on the palette and shown as a value scale. The circle shows these two colors combined on wet paper.

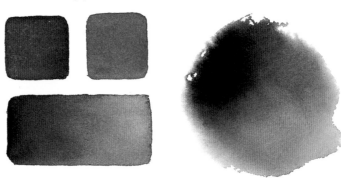

Payne's Gray and Ultramarine Turquoise
The rectangle shows Payne's Gray combined with Ultramarine Turquoise mixed on the palette and shown as a value scale. The circle shows these two colors combined on wet paper.

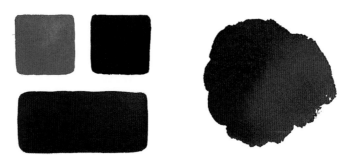

Opaque Oxide of Chromium and Payne's Gray
The rectangle shows opaque Oxide of Chromium combined with Payne's Gray mixed on the palette and shown as a value scale. The circle shows these two colors combined on wet paper. This is one of my favorite mixes for background foliage.

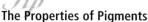

The Properties of Pigments

Knowing a little about the properties of these pigments is important in using them together. Ultramarine Turquoise is a very intense transparent color, on the dark end of the value scale at highest saturation. Green Gold is also transparent, but it is much lighter at its highest saturation. This means that the two colors should blend well, but the Green Gold can be easily overpowered by the intense, more staining turquoise. You'll notice this in both the pre-mixing method and the mixing-on-paper method. Green Gold, while transparent, is not a staining pigment. This means that it lifts off very easily, a characteristic that is apparent when you look at the Ultramarine Turquoise glazed over Green Gold. The color edges have softened a little. If you want the color edges to remain crisp, use a more staining color underneath when glazing.

Mixing Neutrals and Grays

Mixing complementary colors—ones across from one another on the color wheel—will yield grays and browns. For example, Quinacridone Red and Hooker's Green Dark will give you a flat dark brown. You'll find that if you move to one side or the other of the color's complement, you will get a much more interesting neutral hue. Instead of mixing Hooker's Green Dark with the red, for instance, you could combine it with Ultramarine Violet to make a clear gray. With this method you'll get an extensive array of neutral colors which are wonderful for subjects like rocks, dry foliage and old wood. There are a few good out-of-the-tube neutrals, but these colors tend to muddy your palette and should generally be avoided. Also, when mixing grays and browns, keep in mind that mixing more than two colors is likely to give you a muddy result.

Ultramarine Blue and Raw Sienna

Cobalt Blue and Naples Yellow

Manganese Blue Hue and Quinacridone Sienna

Payne's Gray and Burnt Sienna

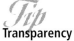

Transparency

Transparency is the characteristic that sets watercolor apart from other media. While acrylic and oil have some transparency, watercolor is the only medium that allows so much light to pass through the paint layers, that light actually bounces from the white paper back to the viewer's eye. This characteristic allows us to use color and texture in all kinds of interesting ways. This transparent quality gives watercolor paintings a special brilliance, almost like stained glass. It also presents the artist with a unique set of challenges. More than other media, watercolor requires forethought and planning. As you work with the pigments, you will discover what you can and cannot do with each color. As you understand each color in your palette, you'll be able to predict which mixtures will create the effects you desire.

Avoiding Mud

One of the most frustrating experiences in the watercolor world is mud. Even the most experienced painters sometimes have problems with muddy color. You would think that mud could be avoided by using only transparent colors, this is not so. Even if you restrict your palette to transparents, there will still be times when you wind up with dull colors.

Here are some secrets to color mixing:

- In general, the safest way to mix watercolor pigments is to blend colors from the same group—like mixing transparents with other transparent or semitransparent colors. Opaque and semiopaque colors like Ultramarine Blue are inclined to muddy your mixtures and should be used with care.

- Do not pre-mix direct complements unless you want gray or brown. Colors adjacent to one another on the color wheel usually mix well, but the closer you get to a color's complement, the closer you get to the mud colors.

- If two transparent complements are applied next to one another and allowed to flow together in a wash, they can work quite well, as seen in both examples.

- If you pre-mix more than two colors, your mixtures can become muddy. Premixing more than two adjacent colors on the color wheel is safer than mixing colors from different parts of the color wheel.

- Introduce sedimentary pigments to your mixtures only if you want the grainy texture.

Quinacridone Red and Hooker's Green Dark
The rectangle shows Quinacridone Red combined with Hooker's Green Dark mixed on the palette and shown as a value scale. The circle shows these two colors combined on wet paper.

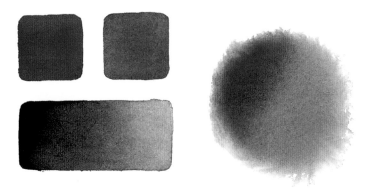

Ultramarine Violet and Hooker's Green Dark
The rectangle shows Ultramarine Violet combined with Hooker's Green Dark mixed on the palette and shown as a value scale. The circle shows these two colors combined on wet paper.

Glazing

In many situations you will want to build up the intensity of a color area or darken its value. The best way to do this is by glazing, adding successive layers of paint and always drying between coats. Obviously, if you use the same color for each layer, you gain more intensity and darker value. But if you use a different color as a glaze, you will change the hue. Knowing this, you can use glazes to make all kinds of subtle color variations. You can use cool glazes to mute other colors, warmer glazes to pull them forward. You can add dimension to forms with translucent shadows. The pigments that work best for glazing are the transparent colors. Opaque colors will screen out the underlying color. If a glaze is applied over an opaque color, it will lift and blend into the glaze wash.

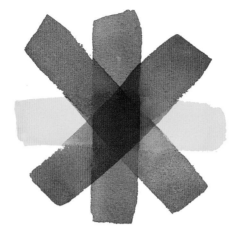

Many Layers Become Opaque
You can use several glaze coats and several different colors as long as you dry thoroughly between coats. Here are Dioxazine Purple, Prussian Blue, Quinacridone Red and Hansa Yellow Light. Notice that the center has become very opaque with four different coats of color.

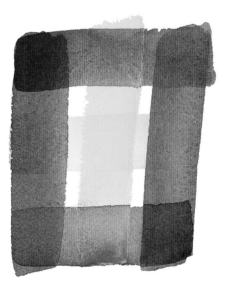

Change Hues Through Glazing
Prussian Blue, Quinacridone Red and Hansa Yellow Light applied in three bands, then glazed with bands of the same three colors. Notice that while the glaze changes the hue, it allows the underlying color to show through for a stained-glass effect.

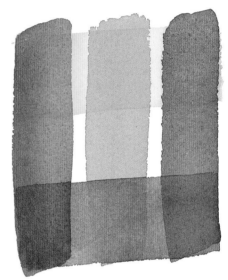

Light Glazes Advance While Dark Glazes Recede
Quinacridone Red, Hooker's Green Dark and Prussian Blue bands glazed with Hansa Yellow Light and Payne's Gray. Notice that the yellow glaze makes the colors advance visually, while the gray glaze causes them to recede.

Glazing
Glazing should be done with a quick, light stroke to avoid lifting the underlying color. It is important to make sure the first layer is bone dry before you glaze.

Sedimentary Interactions

When sedimentary pigments are added to a mix, some interesting interactions can occur. Sedimentary colors are made up of suspended particles that settle out in a wash and have a grainy texture. When two are used together on wet paper, the texture is amplified. You can take advantage of these effects for foliage, rocks and many other surfaces, using them to create a spontaneous texture without any brushwork. On the other hand, when your aim is a clear, even wash, you'll want to avoid the sedimentary colors.

Sedimentary Pigments
Sedimentary colors can create some very different effects depending on how and where they are mixed. Notice the variations between Cobalt Blue and Burnt Sienna when mixed on wet paper (left), on dry paper (center), and on the palette (right).

Mixing Sedimentary Colors With Transparent Colors
Manganese Blue Hue mixed on the paper with a transparent color, Quinacridone Gold.

Mixing Sedimentary Colors With Each Other
Manganese Blue Hue with Raw Sienna, another sedimentary color.

What You Can Do With Color

The possibilities with color are endless. When you design a painting, you plan a composition around a central idea. Your center of interest can be emphasized by the colors you choose. You can also use color to de-emphasize an element of your composition or to make it recede, as in the case of background foliage. Repetition of color can unify a design or add a strong directional element. Remember that using complementary colors—opposites on the color wheel—will make both colors appear brighter. Analogous colors—colors adjacent to one another on the color wheel—will create a harmonious effect. You can completely change the character of a painting with color, using warm tones and bright highlights for a sunny feel, and cool, muted tones for a moody effect. Your color scheme is as important as your idea, so give it careful thought.

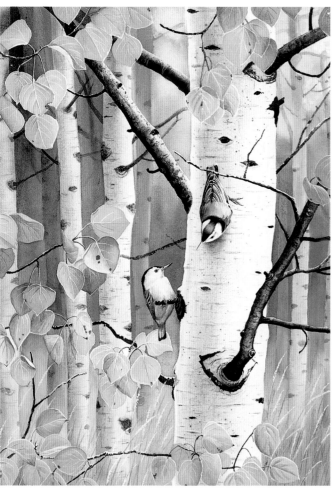

Analogous Color Scheme
This is an analogous color scheme, utilizing colors adjacent to one another on the color wheel. All of the foreground colors are warm, while the background colors are made to recede by the use of cool shades.

AUTUMN GOLD
White-Breasted Nuthatches
Watercolor on Arches 300-lb. (640gsm) cold-pressed paper
21" x 15" (53cm x 38cm)

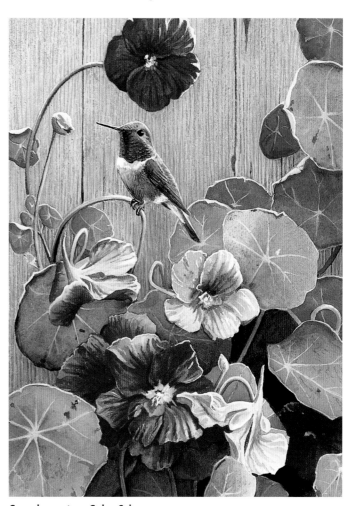

Complementary Color Scheme
Here, the complementary color scheme, choosing two dominant colors directly across from one another on the color wheel, gives strong emphasis to the subject. The background, composed of tones of the same colors, shows the use of sedimentary texture.

RUFUS HUMMINGBIRD AND NASTURTIUMS
Rufus Hummingbird
Watercolor on Arches 300-lb. (640gsm) cold-pressed paper
13" x 6" (33cm x 15cm)

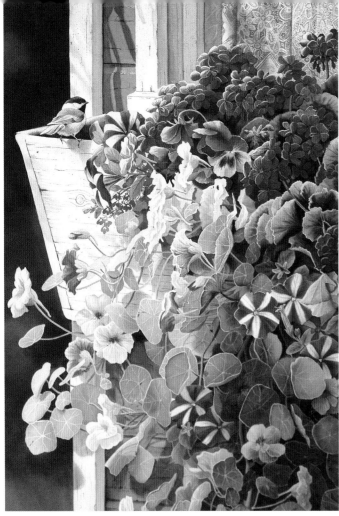

Intense Colors

This riot of color was created by using intense color for the flowers—Quinacridone Pink, Hansa Yellow Light, Hansa Yellow Deep and Ultramarine Violet. So the rest of the painting wouldn't compete, I chose more subtle tones. The background illustrates the use of Oxide of Chromium and Payne's Gray to create a more subdued dark green.

WINDOW GARDEN
Black-Capped Chickadee
Watercolor on Arches 300-
lb. (640gsm)
cold-pressed paper
39" x 19" (99cm 48cm)

Sedimentary Colors

This rust effect is an illustration of how the natural graininess of sedimentary pigments can be used to your advantage. The colors used for the old pump were Burnt Sienna, Raw Sienna, Cobalt Blue and Quinacridone Sienna.

GETTING RUSTY
American Goldfinches
Watercolor on Arches 300-
lb. (640gsm)
cold-pressed paper
21" x 15" (53cm x 38cm)

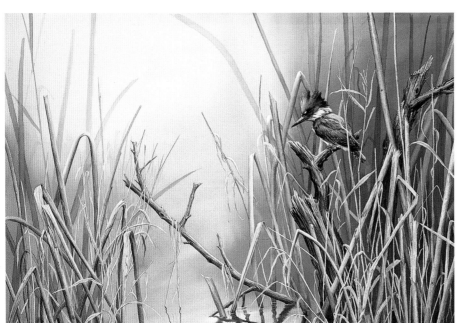

Limited Palette

An interesting color concept to try is the limited palette, employing just a few colors. Cool Payne's Gray tones set the mood for the foggy scene.

KINGFISHER'S THRONE
Belted Kingfisher
Watercolor on Arches 300-lb. (640gsm) cold-pressed
 paper
22" x 30" (56cm x 76cm)

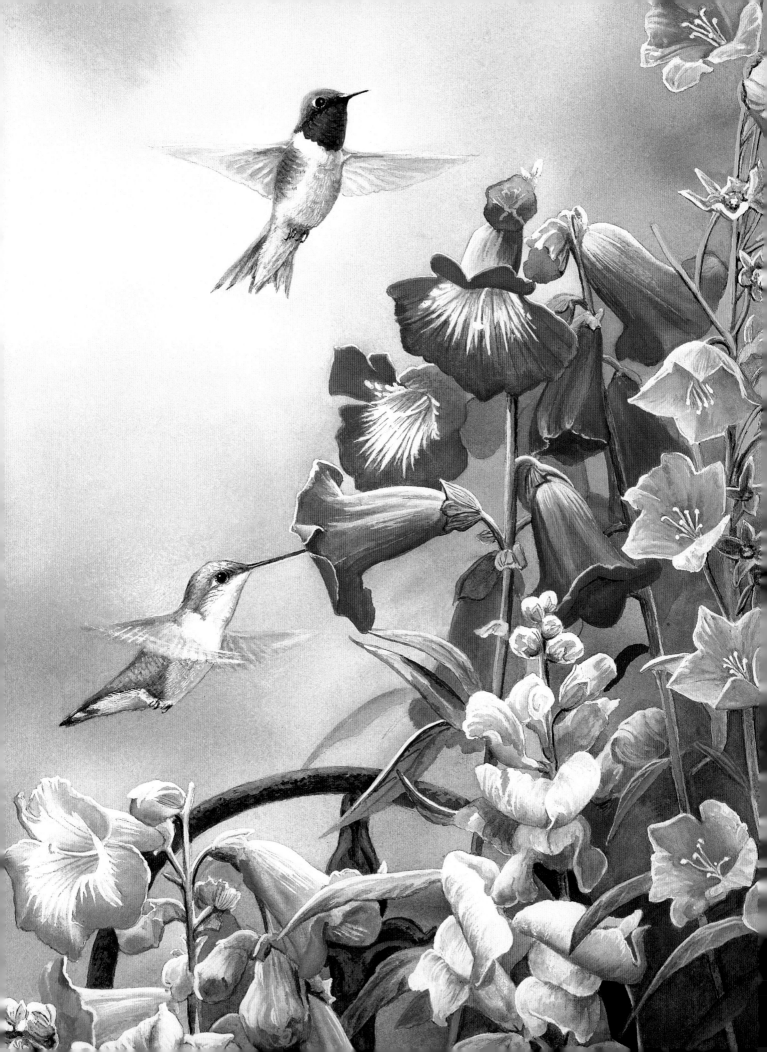

Ideas From Nature

&very painting has to have a beginning—an inspiration. Since the most important ingredient for any piece of art is a great idea, I make a point of deliberately searching for exciting material. Since inspirations for paintings are usually the result of something I've seen in nature, I find that the more time I spend outside with my camera and sketchbook, the more ideas I have in my arsenal.

VICTORIAN SEASONS—SUMMER
Ruby-Throated Hummingbird
Watercolor on Arches 300-lb. (640gsm)
 cold-pressed paper
21" x 15" (53cm x 38cm)

Resources, Research and Equipment

Every painting requires some research—some of it out in the field or in your own backyard with your camera and sketchbook, and some of it in the studio with lots of other support materials. Photographs are a wonderful tool for paintings. I use metal file boxes that allow me to index my 4" x 6" (10cm x 15cm) photos under lots of categories like bird species and flower types. I also have an extensive library of other artists' work from the masters to the more contemporary. In addition, I have lots of field guides and specialty nature books. Other resources come in human form, like naturalists and bird organizations.

I always take along the following items when I research on location:

- 35mm SLR camera. You need an SLR camera so you can accurately compose your photographs.
- 75—300mm zoom lens. This should be versatile enough so that you can leave it on the camera for habitat shots as well as for bird photos.
- Holster-type camera bag that you can strap around your waist, leaving your hands free.
- Tripod or monopod. These are not essential but helpful for feeder shots and zoo photography.
- Sketchbook and simple, portable drawing materials.
- Binoculars
- Film. You will need either 35mm slide or print film, depending on how you want to store your reference photos; film speed should be decided by light conditions.
- Spare camera battery
- Pocketed vest
- Pocket-sized field guide

When researching ideas closer to home I use many different resources. Some of my favorites are:

- National Geographic *Field Guide to the Birds of North America* (National Geographic Society) or National Audubon Society *Field Guide to North American Birds* (Albert A. Knopf, Inc.)
- *Artist's Photo Reference—Flowers* (North Light Books) and *Artist's Photo Reference—Birds* (North Light Books)
- Art magazines like *Wildlife Art, US Art, InformArt* and *The Artists' Magazine*
- Wildflower field guide
- Birder's magazines like *WildBird* and *Audubon*
- Objects brought in from the field to use as props—avoid endangered plants
- The Audubon Society chapter in your local area
- Your personal bird feeders
- Other people's bird feeders
- Zoos, aviaries, city parks and wildlife refuges, raptor and wildlife rehab centers

In the Field
Here I am with my camera in the field searching for interesting birds and wildflowers I can use in future paintings.

Tip
Working From Photographs
One of the questions I am often asked is if I work from photographs. Some people have the idea that photos make the painting process less creative—that all the artist needs to do is copy the photo. If you get out into nature and really look for ideas and elements that can be used in your paintings, photos are a quick way to record what you see—especially birds and wildlife that won't stand still for a sketch! Your snapshots don't absolve you from doing sketches and, as you will see, sketches are vital to the creative process. Reference photos document details, adding to your knowledge of the subject. By taking your own photographs, you take control of the process from the very beginning because the photo, too, is your original artwork.

Bird Feeders

Bird feeders are an excellent source for observing birds. See your local Audubon group or nature store for hints on setting up your own feeder.

Flower Beds

You can easily grow your own photo references in your yard.

Composing From Reference Materials

It's a rare thing when you're able to get bird and setting together in the same photo. More often, you'll be combining several photos taken at different times and places. Use the following tips to help you successfully combine reference materials:

- When selecting a bird reference and setting to combine, look first for a setting that shows the right kind of habitat and has enough going on to make the painting interesting. Sometimes you have to go back to your file for additional material, say the right old fence or other prop.
- Look for similar lighting. If you have the light coming from one direction in the setting and hitting the bird from another angle, you'll have to change one or the other.
- Make sure the viewer's angle is the same on both subject and setting. It doesn't work to look up at the bird's belly and down at the tops of the flowers it is perched on.
- Always do a series of thumbnail sketches to iron out problems.

Example 1
This small chickadee painting is an easy one, combining only a few references.

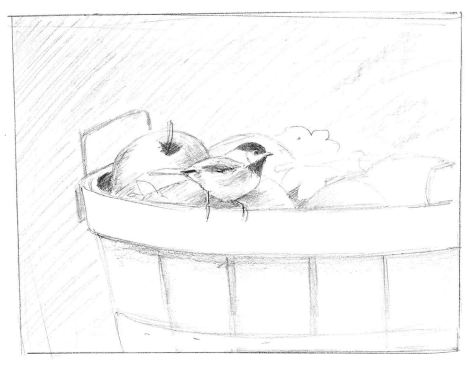

Reference Materials for *Overseeing the Harvest*
Once you have your great idea and some references to work with, you're ready to combine them into a composition. Make your thumbnail sketch as a blueprint first. The sketch helped me choose the right chickadee to perch on the basket edge and determine where I'd need the strongest contrast to make the bird stand out.

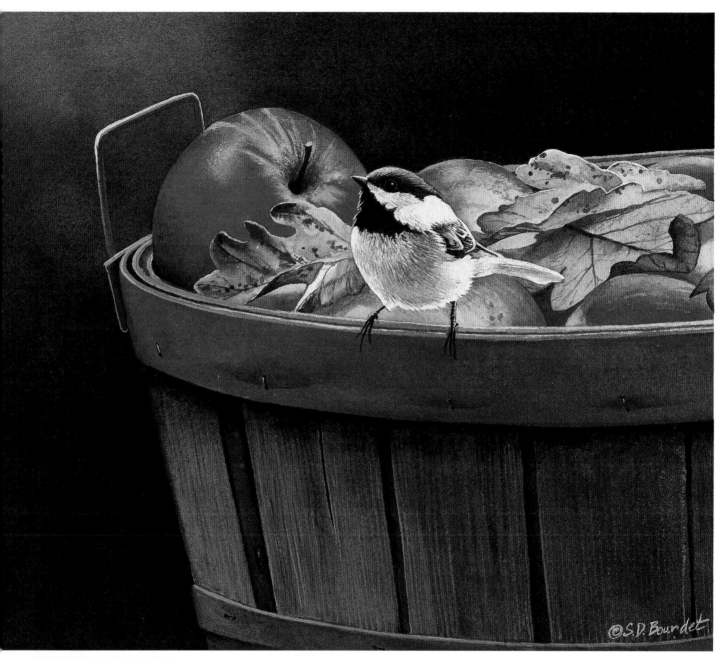

OVERSEEING THE HARVEST
Blacked-Capped Chickadee
Watercolor on Arches 140-lb. (300gsm) cold-pressed paper
9" x 12" (23cm x 30cm)

Example 2

I got this series of pictures in Yellowstone National Park the summer after a big fire. While much of the landscape was sadly scorched, the wildflowers were more beautiful than I have ever seen them—probably from the extra nutrients the fire deposited in the soil.

Reference Material for *Wrens and Wild Roses*
For interest, I wanted to include this dead tree with its bits of blackened bark. I decided to use two house wrens because they would be appropriate for the undergrowth setting and would be paired at the time the wild roses bloom.

Because I was combining several unrelated elements, my sketch was imperative to help me choose the most interesting arrangement.

Tip

Beware of Linear Elements
Whenever you use a linear element like a branch or a log, you have to be aware that this bold directional can point the eye away from the center of interest. You can break up the line with grasses. Also be careful not to cut the painting in half, either vertically or horizontally—I have seen lots of paintings bisected by logs and trees!

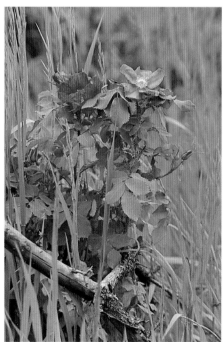

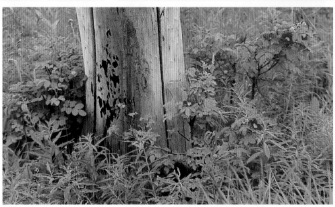

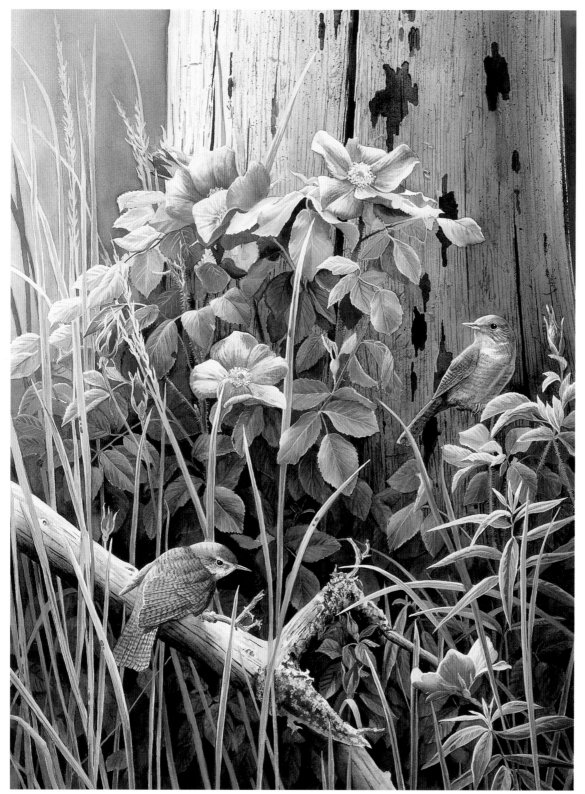

WRENS AND WILD ROSES
House Wrens
Watercolor on Arches 300-lb. (640gsm) cold-pressed paper
19" x 14" (48cm x 36cm)

Example 3

This composition required a whole series of references and is an example of how you can combine material from lots of different sources. Be sure to sketch and photograph all kinds of things that interest you, as you can sometimes combine them in unexpected ways. Keeping the photos in a well-organized file will ensure that you can find them easily, even if the shots are a few years old.

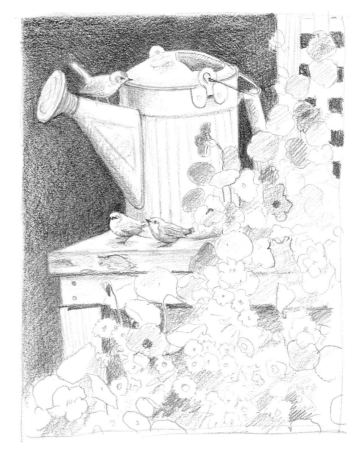

Reference Materials for *The Runaways*

Catching these baby wrens on film was a thrill. The watering can is an antique, which adds a touch of nostalgia to the setting. I liked the pink-orange color combination and the cascading effect of these nasturtiums. A series of sketches of my various ideas helped me to make decisions about what material should be included and what elements should be eliminated in the final composition. I started with only the baby wrens and then decided that it would be more interesting to see an agitated mother overseeing their adventure. I needed to change the position of her tail to make her look more excited. I started with pots of pansies, but that choice left the lower part of the painting colorless and uninteresting, so I opted to use the nasturtium reference.

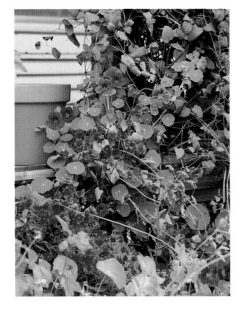

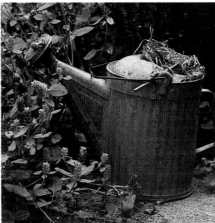

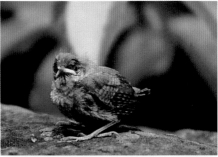

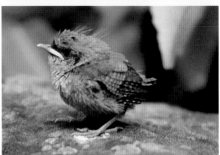

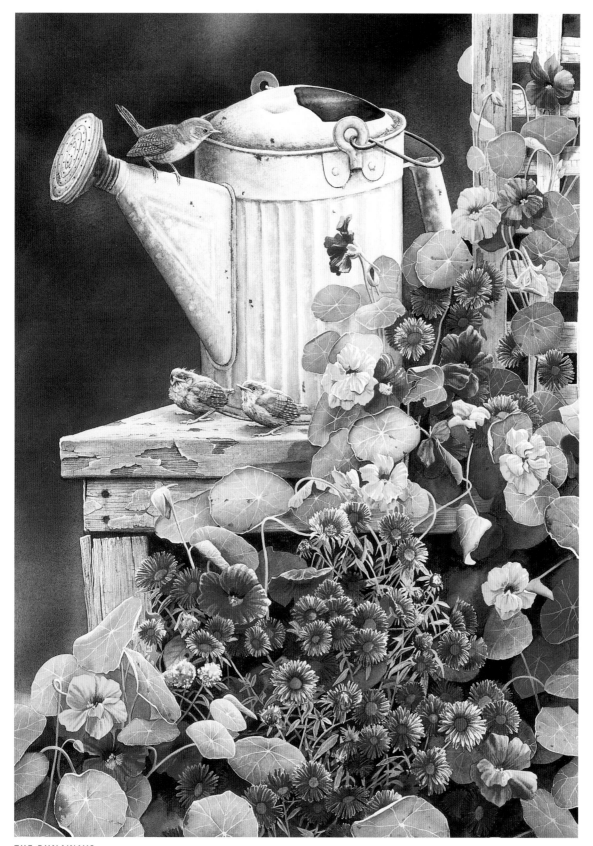

THE RUNAWAYS

House Wrens

Watercolor on Arches 300-lb. (640gsm) cold-pressed paper

30" x 21" (76cm x 53cm)

How to Design a Good Painting

Your reference material is the equivalent of the ingredients in a cake—the magic is in how you blend them. You must use your own unique vision to form the materials into a cohesive whole. While there is no perfect recipe for success, here are some pointers that can help you avoid some common pitfalls and stay in a kind of compositional safety zone. Don't always play it safe—artists, like chefs, need to follow their own intuition.

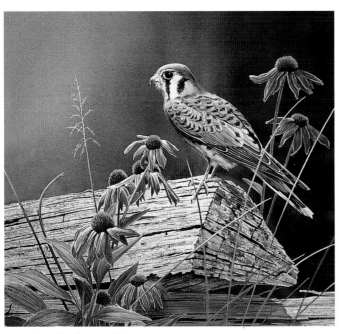

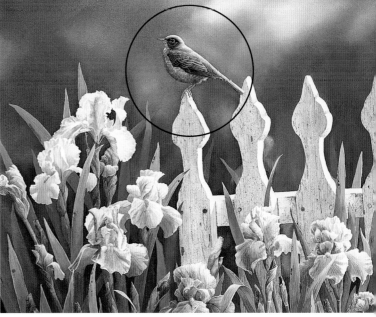

Arranging the Composition

When you arrange the objects in your composition, make the arrangement informal and off-center. When you plan the colors and values, remember that, like the objects, space, color and value have visual weight that can be used to create balance in the composition. In many watercolors, for example, one side of the painting is open space, defined only by a wash of color.

KESTREL AND CONEFLOWERS
American Kestrel
Watercolor on Arches 300-lb. (640gsm)
 cold-pressed paper
15" x 17" (38cm x 43cm)

Center of Interest

Every painting must have a center of interest. Before you paint, decide what it is and how you will emphasize it.

EARLY BIRD
American Robin
Watercolor on Arches 300-lb. (640gsm)
 cold-pressed paper
22" x 30" (56cm x 76cm)

Interaction Between Focal Points

If you use an idea with two focal points, make one of the interest points more dominant. You can do this by placing it in a more important part of the painting or by giving it extra emphasis. Having some interaction between the center of interest and the other focal point can help to unify the painting.

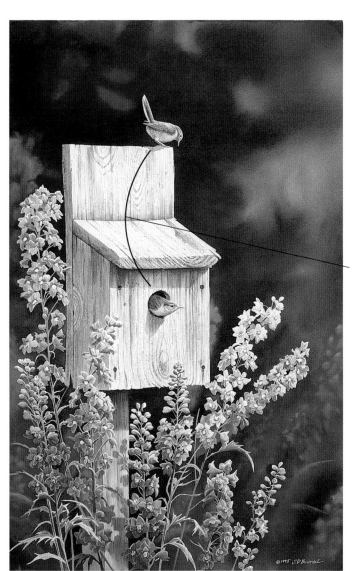

HOUSEHUNTING
House Wrens
Watercolor on Arches 300-lb. (640gsm)
 cold-pressed paper
22" x 15" (56cm x 38cm)

*interaction to unify
the concept*

Place Floral Elements Carefully

If you are painting a floral botanical composition, a good rule of thumb is to have the plants go off the page on at least two sides of the painting. This will prevent the sort of composition where the plants grow up from the bottom of the page in an unnatural fan shape. By this method, you can project the viewer's eye to the growing flowers or branches, rather than having them look like a contrived floral arrangement.

MIDAS TOUCH
Orange-Crowned Warbler
Watercolor on Arches 300-lb. (640gsm)
 cold-pressed paper
15" x 17" (38cm x 43cm)

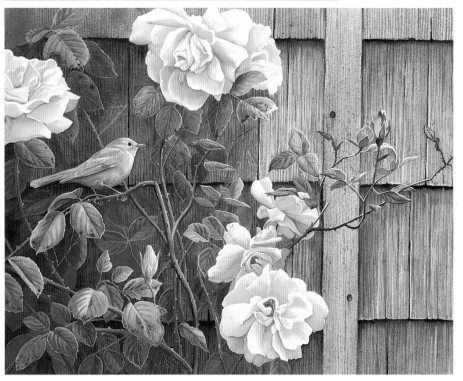

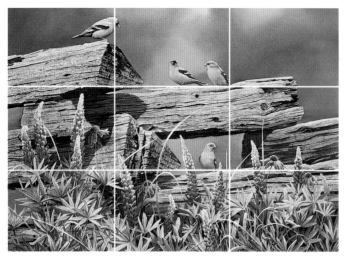

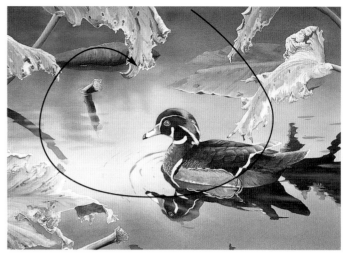

Rule of Thirds

Unless you want the viewer to look only at the middle of your painting, don't place your subject right in the center. It often works well to divide the field of your painting into thirds. The points where your lines intersect are safe places to put your subject.

**RAIL FENCE
RENDEZVOUS**
American Goldfinches
Watercolor on Arches 300-
lb. (640gsm) cold-
pressed paper
18" x 28" (46cm x 71cm)

Move the Viewer's Eye Around

Since your job as an artist is to get the viewer to look at your whole creation, position the various elements of your composition to move the viewer's eye around the painting. Avoid elements that pull the eye out of the visual field, detract from the subject or intersect in a distracting way. Direct the attention to the center of interest in an informal, not too obvious way.

TRANQUIL WATER
Wood Duck
Watercolor on Arches 300-
lb. (640gsm) cold-
pressed paper
22" x 29" (56cm x 74cm)

Abstract Shapes

The shapes, considered as abstract forms, are the building blocks of your design. Be aware not only of the positive shapes created by the objects themselves, but also of the negative shapes—the spaces between objects. Space objects unevenly to echo the randomness of nature.

UPS AND DOWNS
Downy Woodpeckers
Watercolor on Arches 300-lb. (640gsm)
cold-pressed paper
21" x 15" (53cm x 38cm)

strong diagonal shape *abstract negative shapes*

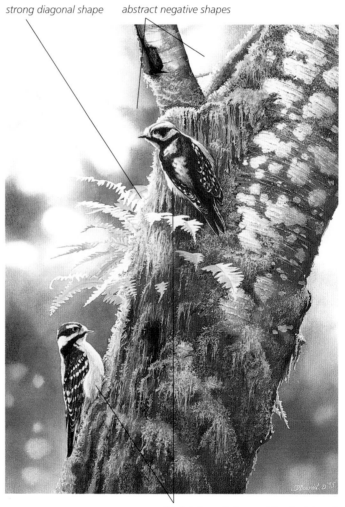

birds intersect diagonal line for interest

Tip
Careful Planning as Preventative Medicine

I'm a big fan of preliminary sketches and careful planning. What attracted me to watercolor in the first place was the dazzling, spontaneous magic I saw when I watched a demonstration of the wet-into-wet technique. Somehow, I got the idea that watercolor was all about total freedom. Later, the school of hard knocks taught me that if I wanted my paintings to look like anything recognizable, if I didn't want all of the paint on my shoes instead of on the paper, I would have to plan my paintings before I got into the wet stuff. In watercolor, you have to make the design decisions first, no matter how anxious you are to get into the actual painting process. Remember that all that beautiful spontaneity can only happen if you are relaxed and sure of your composition. Thumbnail sketches will ensure that you have a good composition to work with.

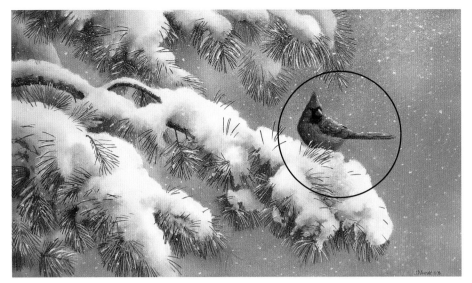

Color and Contrast

Use color and contrast to emphasize your point of interest. Generally, where you want emphasis, you can use contrast—light against dark and dark against light—to draw the viewer's eye. Bright color has the same effect, so it usually works best to mute background colors while making colors more intense on or near the subject.

DECEMBER DUSK
Northern Cardinal
Watercolor on Arches 300-lb. (640gsm)
 cold-pressed paper
21" x 15" (53cm x 38cm)

Soft washes are sometimes enough. *Dark values have weight.*

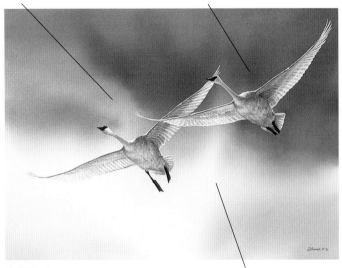

Rest areas for the eye are important.

Soft Wash

All areas should be interesting, but avoid cluttering the visual field with too many objects and details. A soft wash is beautiful and interesting without detracting from your main statement. The eye needs areas of active color and detail, but it also needs restful areas—watercolor is wonderful for this.

FREE FLIGHT
Tundra Swans
Watercolor on Arches 300-lb. (640gsm)
 cold-pressed paper
22" x 29" (56cm x 74cm)

Finding Minor Points of Interest

If your design has several minor points of interest in addition to the main one, try making an "X" from one corner of the painting to the other and locating the minor interest points along the lines, avoiding the center third of the painting.

SCARLET AND SNOW
Northern Cardinals
Watercolor on Arches
 140-lb. (300gsm)
 cold-pressed paper
13" x 7" (33cm x 18cm)

other points of interest

*Background
Techniques
for Nature
Painters*

The purpose of a background is to create a believable foil for your foreground composition—one that enhances the center of interest by providing enough color and contrast to set it off without overpowering it. I carefully paint my backgrounds first, using masking fluid to protect the foreground elements. This technique allows me to create beautiful flowing backgrounds with subtle color variations and minimal details.

This chapter discusses how to use the wet-into-wet technique combined with masking fluid to create beautiful backgrounds. The demonstrations in this chapter utilize some of the same colors but have very different effects. Look closely at different areas of each painting to see the various effects created.

SUMMER BLUES
Ruby-Throated Hummingbirds
Watercolor on Arches 300-lb. (640gsm) cold-pressed paper
28" x 21" (71cm x 53cm)

Painting Wet-Into-Wet

The essence of watercolor is the wash. In order to create successful watercolors you must first understand the delicate balance between pigment and water. There are two basic approaches for applying watercolor paint: One is the wet-on-dry method, where you mix your color to the desired consistency on your palette and then apply it to bone-dry paper. The other is the wet-into-wet method, in which you wet the paper first and then apply the color, previously mixed to the desired consistency, to wet paper. We'll start with wet-into-wet because it is a wonderful technique for watercolor backgrounds.

In this application, the color will *flare* or spread on contact with the wet paper. The paper is first coated with water. The pigments are mixed to the right consistency on the palette and then brushed onto the wet surface, resulting in movement and blending of the colors. The wet-into-wet technique is used when you want a soft-edged, spontaneous effect rather than a controlled, hard-edged effect. I use this technique for most of my backgrounds and also for some of the larger foreground objects in my paintings because it is simply the most efficient way of applying paint to a big expanse of paper. At first, the flare effect can seem a little scary because it is somewhat unpredictable. With a little practice, you'll be able to control how much flare you get, and you'll love the wonderful, spontaneous blends that happen all by themselves. This technique is the magic that sets watercolor apart from all other media.

SEPTEMBER MORNING
Northern Cardinal
Watercolor on Arches 300-lb. (640gsm) cold-pressed paper
22" x 15" (56cm x 38cm)

Wet-Into-Wet Wash

Always begin with good paper, properly prepared. If you're using 140-lb. (300gsm) cold-pressed paper, you will need to stretch your paper as described in chapter one. 300-lb. (640gsm) requires no stretching unless you're doing a very large painting. I like to use 300-lb. (640gsm) for all my wet-into-wet techniques because it is a bit more absorbent than the lighter weight paper, making it better for building-up washes. Be careful in handling watercolor paper, as fingers with any oil or lotion can leave their mark. Scratches and abrasions will also show themselves in your wash because they absorb more pigment than the rest of the sheet.

Using the right brush can make a difference. Make sure you choose a brush size appropriate for the size of the area you're painting. I use a 2-inch (51mm) hake brush for large areas, switching to a no. 10 or 12 round for suggesting foliage shapes. A large wash brush like a 1½-inch (38mm) white sable or Kolinsky sable also works well for large areas. For smaller wash areas, you can use either a 1-inch (25mm) flat sable or a no. 10 or 12 round. You will notice as you experiment with these brushes that the sharp corners of the flat brushes sometimes leave marks in the wash. There are no marks with the hake brush, but it takes time to break in a new one. At first, they have the annoying habit of shedding and will seem too bulky. As the paper abrades the hairs, they become shorter and more tapered, improving their performance.

1 Start with fresh pigments, clean water, a clean palette and all your tools like rags, spray bottle and brushes. Mix water with each color, (Oxide of Chromium, Payne's Gray and Quinacridone Gold), working the individual puddles with your 2-inch (51mm) brush until they are the consistency of thick cream. Make a large enough puddle of each color so you won't have to remix them during the wet-into-wet wash process. Remember that pigments may fade up to 40 percent as they dry. Therefore, a dark wash like this one should not be diluted too much. For pale washes, dilute the pigments more.

MATERIALS LIST		
Watercolors	**Other**	
Oxide of Chromium	Arches 300-lb. (640gsm)	
Payne's Gray	cold-pressed paper	
Quinacridone Gold	Hair dryer	
	Large water container	
Brushes	Old bath towel	
2-inch (51mm) flat Kolinsky sable, white sable or 2-inch (51mm) hake	Palette with large wells and mixing area	
	Water-filled spray bottle	

Tip
Mixing Paint
To prepare large paint puddles, squirt about a teaspoon of fresh pigment on the palette and add an equal amount of water. Work the mixture with your brush, adding more water a little at a time until you have a creamy consistency. When you can drag your brush through the puddle and make a valley that doesn't run together immediately you have the right consistency.

2 Place a large terrycloth towel under your paper. Wet the paper applying the water evenly. To ensure a uniform shine, look at it from an angle to make sure there are no puddles or runs.

Blot your brush slightly before you pick up the pigment to avoid diluting the color. Load the brush well so that you don't have to dab.

Flow the pigment onto the wet paper with 2"—3" (51mm—75mm) strokes, letting the water do some of the work. Avoid over-brushing or scrubbing.

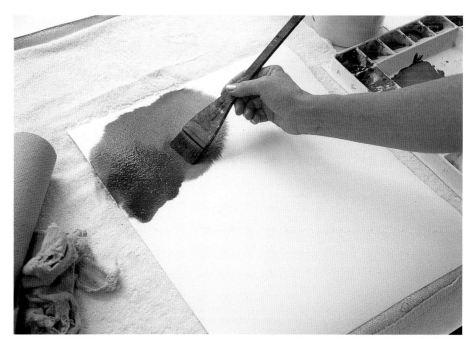

3 While the paper is still shiny-wet, you can add more color or add other colors. The process of adding other colors is called *charging*. Use this technique to suggest leaf shapes or background foliage. Don't get too carried away when charging additional color to suggest foliage. A too complicated background will compete with your foreground rather than enhance it.

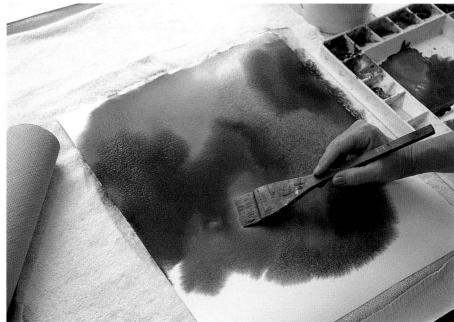

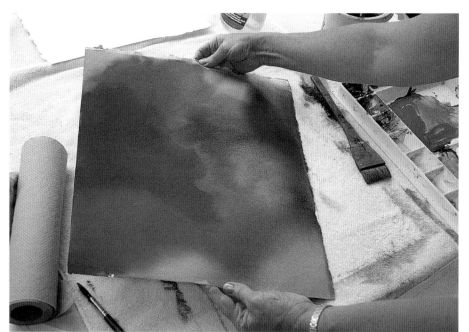

4 You can carefully tilt the paper to create soft blends.

Watermarks
Introducing more color, water or brushstrokes to a damp wash after the wet shine is completely gone will create watermarks. Avoid these by introducing color only when a wash is shiny-wet.

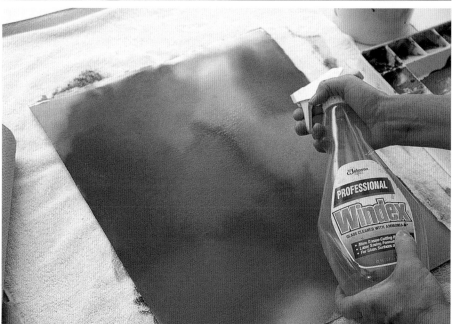

5 If the wash begins to dry before you're happy with it, or if the colors fade more than you'd like, use your hair dryer to dry it until bone-dry—not cool to the touch—then re-wet with your spray bottle. Introduce more color to the sprayed area by brushing it very gently so as not to disturb the first coat. Dry with a hair dryer until it is bone-dry.

Adding Color
If you wish to add color to only part of the background, spray the area, wetting a larger patch than you wish to paint. Introduce the color just to the shiny part of the sprayed area and tilt the paper to create soft blends. The sprayed patch will dry without leaving a watermark because the edges have been finely spattered.

6 Lightly brush on more color. Use a delicate touch to avoid disturbing the first layer of color.

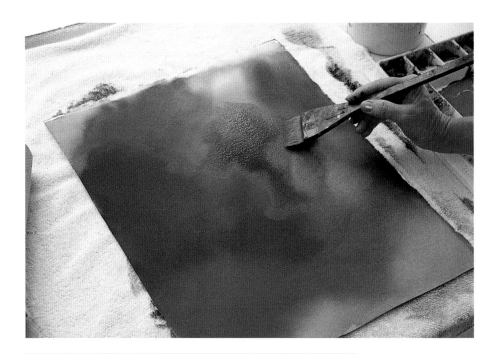

12 Tips
for Successful Washes

1. Be prepared. Always start with fresh pigments, clean water and all the tools you will need.
2. Place a large terrycloth towel under the paper to prevent excess water from leaking back under the paper.
3. Make a mental plan of where you want to apply your colors—think it through before you begin.
4. Mix large puddles of color on your palette, creating smooth, even consistencies.
5. Use separate brushes for each color.
6. Colors applied to wet paper will fade up to 40 percent as they dry, so make your mixtures rich and creamy.
7. Apply the water evenly when wetting the paper to create a uniform shine.
8. Blot your brush slightly before picking up the pigment to avoid diluting the color. Load the brush well so that you don't have to dab.
9. Let the water do the work. Flow the pigment onto the wet paper with 2"—3" (51mm—75mm) strokes.
10. Add more color or different colors while the paper is still shiny-wet.
11. Tilt the paper to create soft blends.
12. Use a hair dryer, moving in a rapid circular motion to dry the surface as evenly as possible.

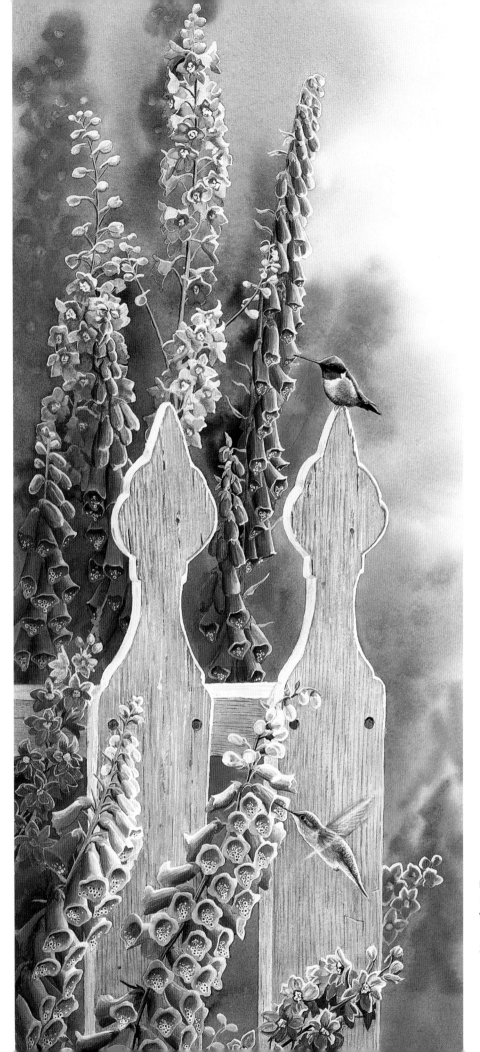

RUBIES AND FOXGLOVE
Ruby-Throated Hummingbirds
Watercolor on Arches 300-lb. (640gsm) cold-pressed
 paper
38" x 15" (97cm x 38cm)

Masking Fluid

Masking fluid is a valuable tool because it allows you to work your washes freely without worrying about painting around difficult shapes. Applying the mask is just a preliminary step that must be done before you get to do the actual painting, but it is actually one of the most important steps in the whole process. This is where you carefully analyze the composition and decide on your order of operations. Since the background needs to be painted first, you will need to save the foreground elements so that you can paint them on clean white paper.

MATERIALS LIST		
Watercolors	**Other**	
Burnt Sienna	Arches 300-lb. (640gsm) cold-pressed paper	
Payne's Gray	Bar soap	
Raw Sienna	Facial tissues	
Oxide of Chromium	Hair dryer	
Brushes	Masking fluid, yellow-tinted	
1-inch (25mm) flat	No. 2 pencil	
2-inch (51mm) hake	Old bath towel	
Old no. 2 synthetic round	Palette	
	Soft rags or paper towels	
	Tracing paper	
	Workable fixative	

1 Use tracing paper to transfer your drawing to watercolor paper. Blacken the lines on the reverse side of the tracing paper with a no. 2 pencil, then turn right side up on the watercolor paper and press the lines through with your thumbnail. Spray the drawing with workable fixative to preserve the pencil lines.

Fixatives
Spray workable fixative very lightly—a heavy coat will seal the paper so it won't accept the watercolor wash. I use Krylon Workable Fixatif because it doesn't seal as much as other brands I have tried.

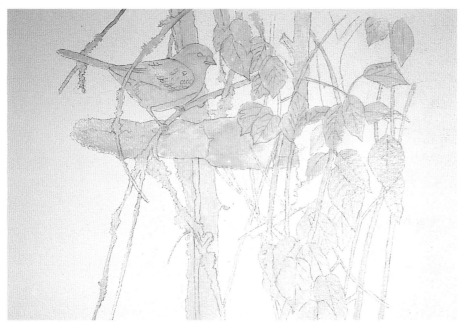

2 Flow on the masking fluid, staying within your pencil lines. Apply an even coat without brushing too much and be careful to pop all air bubbles, as they make pinholes that show up later as dark spots. You don't want the product to be too thin, but you don't want too heavy an application or it won't dry properly. It is much like applying latex house paint.

When completely dry, masking fluid turns from milky to clear yellow. Don't begin to apply your wash until all areas have turned clear.

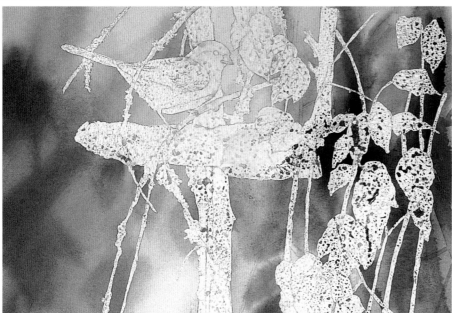

3 Apply the wash as you did in the wet-into-wet wash lesson. Blot paint droplets off of the masked areas with a facial tissue before blow-drying. Dry, keeping the dryer nozzle at least 8-inches (20cm) above the artwork to avoid overheating the mask.

Tip

Blot Unwanted Water Droplets

Use a facial tissue to blot the water droplets off of the masked areas before you dry the wash with the hair dryer. The force of the air from the dryer can push the droplets into the damp wash causing unwanted watermarks that are both ugly and difficult to fix.

4 Gently lift a corner and peel off the mask—you shouldn't have to rub at it—if it won't come off easily, your application may have been too thin or your dryer too hot.

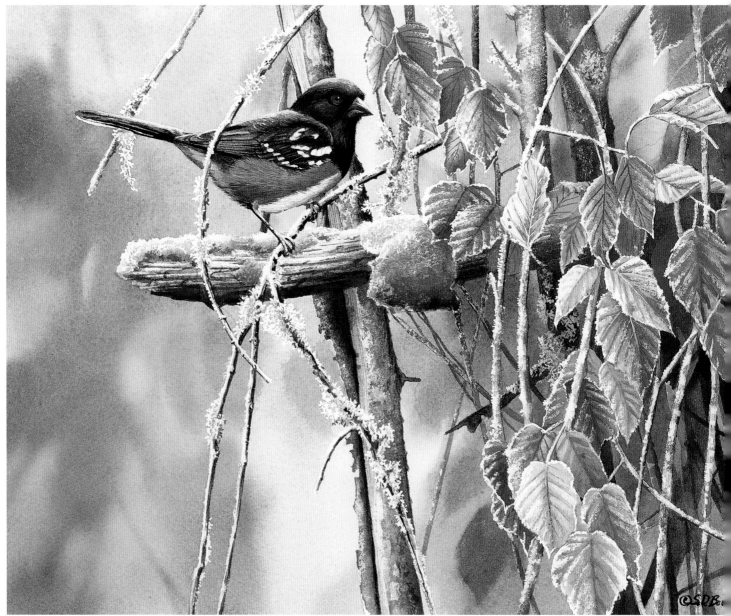

FALL FROST
Rufus-Sided Towhee
Watercolor on Arches 140-lb. (300gsm) cold-pressed paper
15" x 12" (38cm x 31cm)

Suggesting Background Foliage

Payne's Gray, Oxide of Chromium and Burnt Sienna are used to create the subtle illusion of background foliage. This creates an illusion of depth that enhances the foreground features.

Tip
Suggesting Foliage

One of the most effective ways to add depth to your paintings is to use the wet-into-wet method to suggest background foliage. This method helps to unify the crisply painted foreground subject matter with the background, avoiding the cutout look.

MATERIALS LIST

Watercolors
Green Gold
Oxide of Chromium
Payne's Gray

Brushes
No. 10 round
1-inch (25mm) flat
2-inch (51mm) hake or wash brush
Old no. 2 synthetic round

Other
Arches 300-lb. (640gsm) cold-pressed paper
Bar Soap
Facial tissues
Hair dryer
Masking fluid
No. 2 pencil
Old bath towel
Palette
Soft rags or paper towels
Water-filled spray bottle
Workable fixative

1 Complete your drawing and spray with workable fixative. Apply the masking fluid.

2 Apply a light base wash of Payne's Gray, suggesting shadowy forms at the left. Leave the right side very light.

3 Allow the paper to absorb the water for a few minutes. Before the shine dries, paint some leaf shapes using a mix of Oxide of Chromium and Green Gold. If the first leaf shape flares too much, wait a little longer before painting the rest. Dry the painting with a hair dryer.

4 Re-wet with the spray bottle, and brush in some darker values, building up the wash to create enough contrast. Dry the painting with a hair dryer. Repeat if necessary, using the spray bottle to re-wet. When you are satisfied with the background, remove the mask.

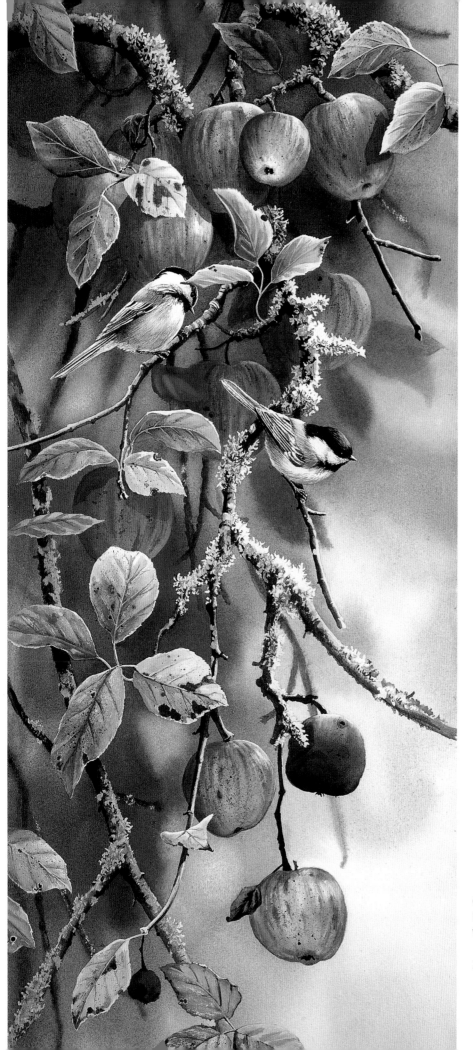

CHICKADEES AND APPLES
Black-Capped Chickadees
Watercolor on Arches 300-lb. (640gsm)
 cold-pressed paper
24" x 10" (61cm x 25cm)

Creating the Illusion of Depth in a Background

You can create interesting backgrounds that give the viewer a sense of depth by creating shadows, using Payne's Gray, Prussian Blue and Winsor Violet. To create an illusion of depth you can use a light to medium base wash to create background leaves or other shapes in darker values. Placement of these darker strokes is very important, because you want more contrast behind the key elements of the painting.

MATERIALS LIST	Watercolors	Other
	Prussian Blue	Arches 300-lb. (640gsm) cold-pressed paper
	Payne's Gray	Bar soap
	Winsor Violet	Facial tissues
		Hair dryer
	Brushes	Masking fluid
	No. 10 round	No. 2 pencil
	1-inch (25mm) flat	Old bath towel
	2-inch (51mm) hake or wash brush	Palette
	Old no. 2 synthetic round	Soft rags or paper towels
		Water-filled spray bottle
		Workable fixative

1 Complete your drawing, spray with workable fixative and apply masking fluid.

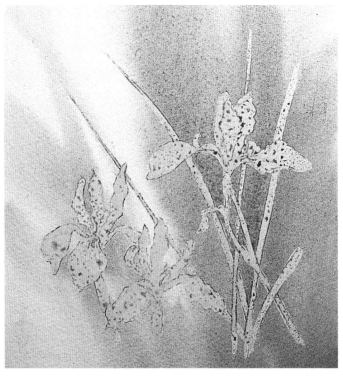

2 Combine Payne's Gray and Prussian Blue to create a pleasant mix. Apply the mixture to suggest background reeds.

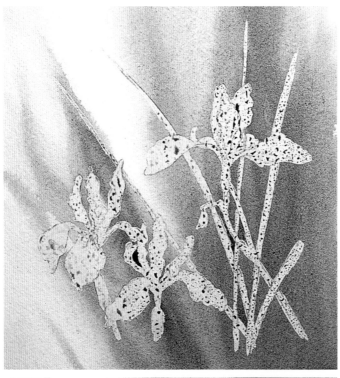

3 While still wet, suggest more reeds with a mix of Winsor Violet and Payne's Gray. Dry using a hair dryer.

4 Re-wet with the spray bottle, and then build up the values with a mix of Payne's Gray and Prussian Blue along the right side. Dry with a hair dryer. Remove the masking fluid.

Creating an Illusion of Depth

One of the biggest challenges we face in painting backgrounds is to give the viewer the illusion of three dimensions. This is achieved by suggesting shadowy shapes and by choosing background values that create depth by receding visually.

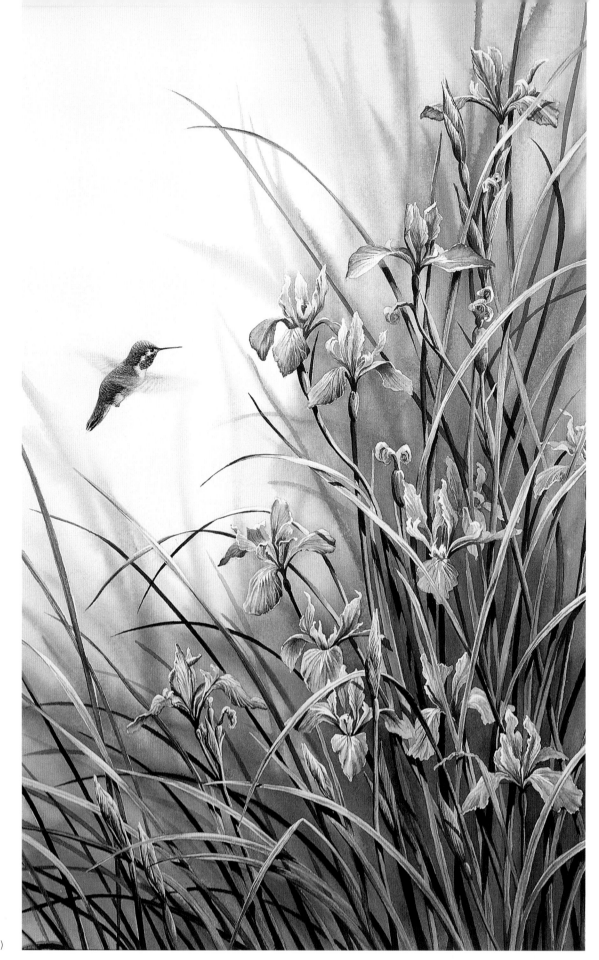

WILD GARDEN
Calliope Hummingbird
Watercolor on Arches
300-lb. (640gsm)
cold-pressed paper
15" x 21" (38cm x 53cm)

A Dark Background for Dramatic Contrast

When using a very dark background, the approach changes slightly. Instead of starting with a light base wash, you'll mix your color puddles to a much thicker consistency, then apply the colors directly to the areas where you want them, tilting the paper to create soft blends. This technique can add emphasis and drama to the center of interest. A perfect contrast for delicate birds and flowers!

MATERIALS LIST	Watercolors	Other
	Cobalt Blue	Arches 300-lb. (640gsm) cold-pressed paper
	Green Gold	
	Oxide of Chromium	Bar soap
	Payne's Gray	Facial tissues
	Permanent White gouache	Hair dryer
		Masking fluid
	Brushes	No. 2 pencil
	No. 10 round	Old bath towel
	1-inch (25mm) flat	Palette
	2-inch (51mm) hake or wash brush	Soft rags or paper towels
		Water-filled spray bottle
	Old no. 2 synthetic round	Workable fixative

1 Complete your drawing, spray with workable fixative and apply masking fluid.

2 Mix color puddles on your palette the consistency of thick cream using Payne's Gray, Oxide of Chromium and Green Gold. Wet the paper and apply some patches of Green Gold first, then brush a very dark mixture of Payne's Gray and Oxide of Chromium into the unpainted areas, overlapping the Green Gold with a ragged stroke to simulate foliage. Tilt the paper to create soft blends. Dry with a hair dryer.

Tip
Add Emphasis
You can add emphasis and drama to your center of interest with contrast. A dark background is the perfect foil to set off delicate birds and flowers, allowing you to use sunlight and shadow believably.

3 Re-wet with the spray bottle. Allow to dry until the shine has just gone, then paint, repeating the process from step 2. Dry with the hair dryer.

4 Re-wet one more time with the spray bottle. Allow to dry until the shine has just gone, then paint in the background delphiniums with a mix of Cobalt Blue and Permanent White gouache. Dry with the hair dryer.

BACK TO NATURE

Eastern Bluebird

Watercolor on Arches 300-lb. (640 gsm) cold-pressed paper

16" x 24" (41cm x 61cm)

Painting Flowers & Leaves

*A*rt should come from the heart, it's true. There is a technical side to painting though, and no matter how much heart you put into your work, the results won't please you until you've mastered the basic tools and techniques. For nature paintings, the heart of the matter is sensitive and realistic depiction of the living elements of your composition. In this chapter, we'll take a detailed look at the methods I use for botanical paintings.

SHADES OF SUMMER
American Goldfinches
Watercolor on Arches 300-lb. (640gsm)
 cold-pressed
37" x 16" (94cm x 41cm)

Foreground Techniques

Foreground subject matter requires a controlled approach using smaller brushes and less water. While the shapes and subjects in the foreground are varied, there are some basic techniques that you will use for nearly every subject you tackle.

MATERIALS LIST		
Watercolors Cobalt Blue Quinacridone Pink **Brushes** Nos. 2, 4 and 6 rounds Old no. 1 synthetic round	**Other** Arches 300-lb. (640gsm) cold-pressed paper Bar soap Facial tissues Hair dryer Masking fluid No. 2 pencil Old bath towel Palette Soft rags or paper towels	

1 For many objects in nature, you'll indicate a curved or rounded form by *pulling out*—applying water to paint already on the paper to dilute the color. Apply the color to dry paper in the darkest area of the object and let the stroke of pigment soak in for a few moments.

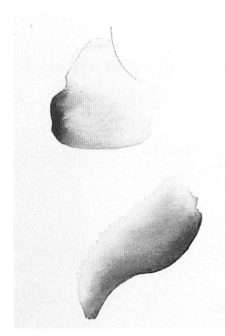

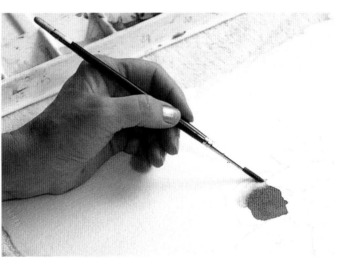

2 While still wet, use a brush wet with water to pull or soften the color out.

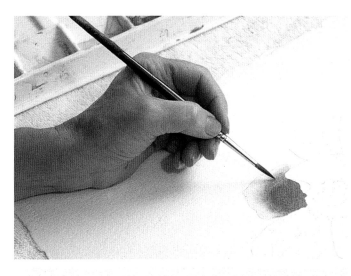

3 If your first pull-out doesn't take away enough color, rinse the brush and repeat. Keep a rag handy to blot excess water from the brush. As you practice, you'll notice that the amount of water you use on the brush can be adjusted to control the amount of flare.

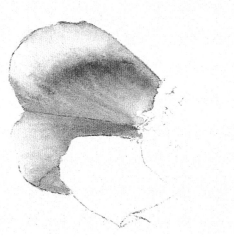

4 You will create most forms by *building up* the washes. The most important part of this process is careful placement of the darks so that they can be pulled out to create contour. Build up the values by applying several pulled-out layers of color, drying between coats. Apply each successive layer so that some of the layer under it is still revealed. Quinacridone Pink was applied to the shadow area of a petal, then pulled inward toward the center to create the concave area and outward to create the convex curve.

5 To build up the form, a mix of Quinacridone Pink and Cobalt Blue was applied to the darkest area after the first wash was dry, then softened at the outer edge and pulled in toward the center.

Flowers—A Basic Approach

Flowers, with their delicate petals, present a unique challenge—painted blossoms can easily look heavy and stiff. Even if the form is well drawn, a painted flower will lose its delicacy if the artist uses a heavy hand. To avoid this problem, build up the washes with thin wash layers of color to retain the transparent quality. Also, keep in mind the direction of the light so that it not only defines the shape of the flower, but also shines through the petals in a few places.

MATERIALS LIST	Watercolors	Other
	Cobalt Blue	Arches 300-lb. (640gsm) cold-pressed paper
	Hansa Yellow Light	Bar soap
	Quinacridone Pink	Facial tissues
	Winsor Violet	Hair dryer
	Brushes	Masking fluid
	Nos. 2, 4 and 6 rounds	No. 2 pencil
	Old no. 1 synthetic round	Old bath towel
		Palette
		Soft rags or paper towels

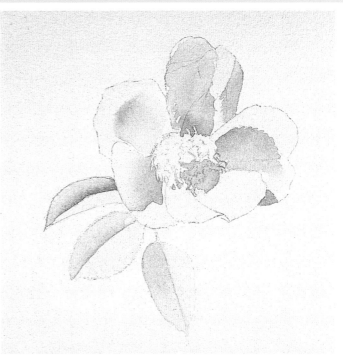

1 Paint pale yellow or pink underwashes on the sunlit areas, and blue or violet underwashes in the shadow areas. To paint adjacent washes without bleeding, make sure the first wash is bone-dry before doing the second.

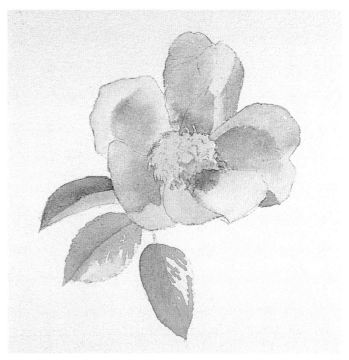

2 Continue the building-up process by adding the lightest values of the flower color over the dried underwash; conserve the highlights using the pulling-out technique.

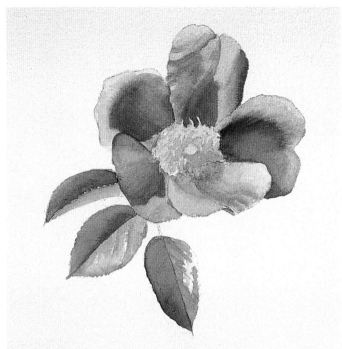

3 While the base wash is still wet, it may be *charged* with more color to enhance the values or to add a blush of color. This is a good way to indicate soft-edged shadows and color variations. (For hard-edged cast shadows, use the wet-on-dry technique without pulling out to keep a crisp edge.) How much flare you get in the charged areas depends on how wet the surface is when you add pigment. If you want more control, use less water. This means that as you progress in the building-up process, you'll use less and less water until, with your finishing touches, you will be softening the edges with a damp brush.

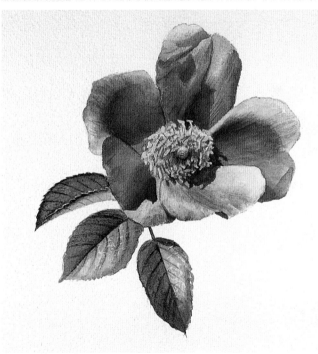

4 By changing the colors and areas of application with each coat and drying between coats, you can glaze the subject with transparent layers, gradually building up the form. Fine details are added once the last glazes are finished.

Lifting

Once a wash is damp-dry, color may be lifted to enhance highlights, using a damp brush to take away color. This works best with non-staining pigments. Lifting can also be done once a wash is dry, by scrubbing gently with a damp brush, then blotting the color away with a tissue.

Iris—Building Up the Flower Form

In this little study, we'll use the pulling-out technique to give shape to the iris petals, then gradually build up the form with layers of color. We'll also learn an easy method for water droplets.

MATERIALS LIST	Watercolors	Other
	Cobalt Blue	Arches 300-lb. (640gsm)
	Quinacridone Pink	cold-pressed paper
	Quinacridone Sienna	Bar soap
	Winsor Violet	Facial tissues
		Hair dryer
	Brushes	No. 2 pencil
	Nos. 2 and 4 rounds	Masking fluid
	Old no. 1 synthetic round	Old bath towel
		Palette
		Soft rags or paper towels
		Workable fixative

1 Complete your drawing and spray with workable fixative. Mask the water droplets. Use the no. 4 round to apply Quinacridone Pink using a wet-on-dry approach for the underwash. Keep the highlights and petal edges light. To preserve the crisp petal edges, dry each area before painting another.

2 Dampen the individual petals again and apply a wash of Winsor Violet to the shadow areas, pulling out toward the highlights and being careful not to cover all of the pink.

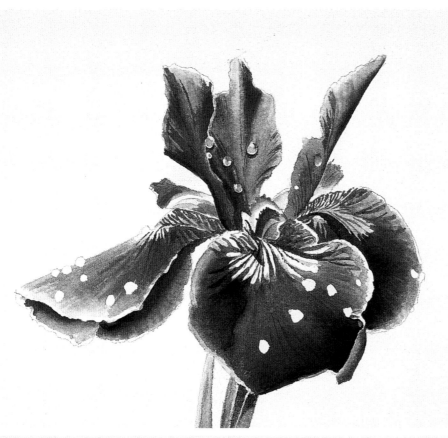

3 Paint the darkest shadows with darker Winsor Violet and charge with Cobalt Blue. Apply these colors to the dry paper, and then pull out with a damp brush to soften them into the rest of the flower.

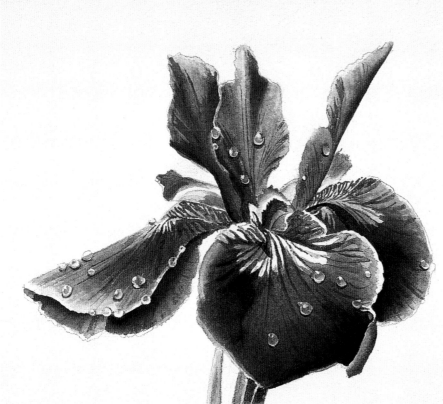

4 Use the no. 2 round to detail the striped area at the top of each petal with Quinacridone Sienna and paint in the stripes at the throat with Winsor Violet. The flower is complete.

Tip
Water Droplets

A water droplet is masked while the rest of the flower is painted, then painted with the light pink flower color, leaving a tiny highlight. While still damp, the tiny droplet wash is charged with a minute touch of violet, again leaving the highlight. After it dries, a narrow rim of shadow is added underneath.

Daisies—Defining Shapes With Shadow and Contrast

These simple daisies are dramatic against a dark background. The crisp white of the paper contrasts nicely with the cool blue shadows. For white subjects, shape and form are indicated by painting the shadow areas, leaving the white paper to represent the highlights.

MATERIALS LIST	Watercolors	Other
	Cobalt Blue	Arches 300-lb. (640gsm) cold-pressed paper
	Hansa Yellow Light	Facial tissues
	Payne's Gray	Hair dryer
	Quinacridone Gold	No. 2 pencil
	Brushes	Old bath towel
	Nos. 2, 4 and 6 rounds	Palette
		Soft rags or paper towels

1 Cool underwashes and details work well to enhance white flowers. Use a mixture of Payne's Gray and Cobalt Blue on the shadows, then dry and detail those areas with the same mixture.

2 Wet the centers, then apply an underwash of Hansa Yellow Light. Glaze the shadow areas with Quinacridone Gold.

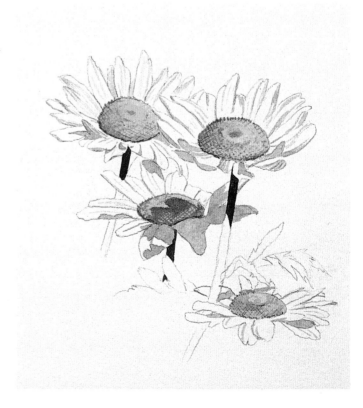

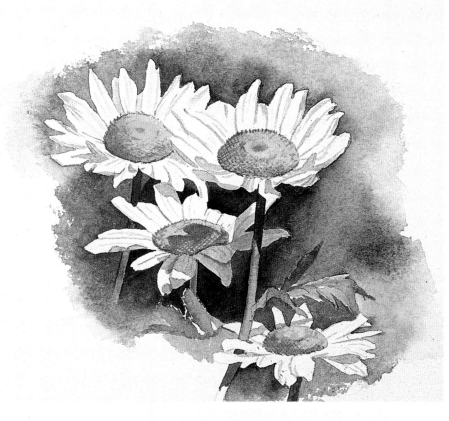

3 A contrasting background makes the flowers stand out.

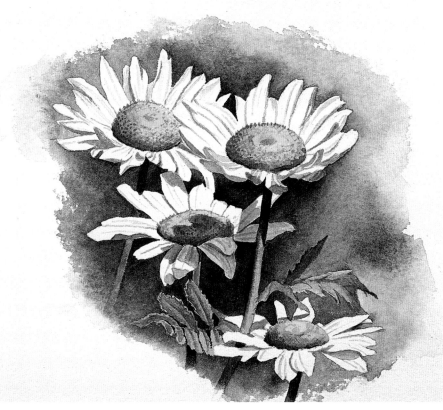

4 Add final details with Quinacridone Gold to the centers after they've dried.

Apple Blossoms—Charging in a Delicate Blush of Color

Many flower petals are streaked or delicately tinted. This effect can be created by charging—adding a stroke of color to the dampened petal for a soft-edged blush.

MATERIALS LIST		
Watercolors	**Other**	
Hansa Yellow Light	Arches 300-lb. (640gsm) cold-pressed paper	
Hooker's Green Dark		
Payne's Gray	Facial tissues	
Quinacridone Pink	Hair dryer	
Quinacridone Sienna	No. 2 pencil	
Sap Green	Old bath towel	
	Palette	
Brushes	Soft rags or paper towels	
Nos. 2 and 4 rounds		
	Workable fixative	

1 Complete your drawing and spray it with workable fixative. Use the no. 4 round to paint the shadows with a mixture of Payne's Gray and Cobalt Blue. Dry with a hair dryer.

2 Paint the next wash on the leaves with Sap Green and charge with Hooker's Green Dark. Working on one petal at a time, dampen the area slightly and then charge in Quinacridone Pink here and there for a streaked effect.

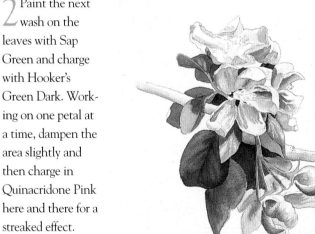

3 Detail the flower centers with Hansa Yellow Light and Quinacridone Sienna using the no. 2 round.

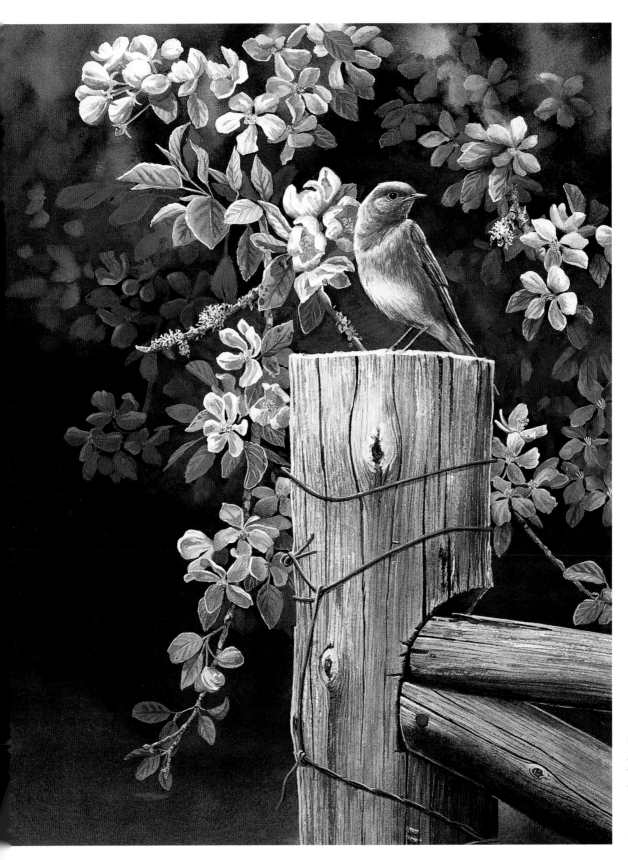

**BLUEBIRD AND
APPLE BLOSSOMS**
Western Bluebird
Watercolor on Arches
300-lb. (640gsm)
cold-pressed paper
26" x 18" (66cm x 46cm)

Blackberry Leaves—Charging and Lifting Out to Create Highlights

Leaves are often ignored or painted in a stiff, uniform manner while the artist concentrates on the flowers. Capture the beauty of leaves by drawing them accurately, striving for relaxed, natural positions. Pay attention to how the light strikes each leaf surface. Good references will help, so don't forget to photograph leaves as well as flowers and birds.

MATERIALS LIST		
	Watercolors	**Other**
	Burnt Sienna	Arches 300-lb. (640gsm) cold-pressed paper
	Hooker's Dark Green	Bar soap
	Green Gold	Facial tissues
	Brushes	Hair dryer
	Nos. 2, 4 and 6 rounds	Masking fluid
	Old no. 1 synthetic round	No. 2 pencil
		Old bath towel
		Palette
		Soft rags or paper towels

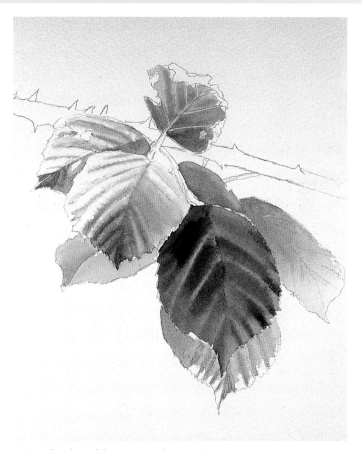

1 Mask a few of the veins with a no. 1 synthetic round. Dry with a hair dryer.
 Use the no. 6 round to dampen one leaf at a time and paint the underwash, using diluted Hooker's Green Dark for the light areas, then charge in concentrated pigment for the shadow areas. For the yellower leaves, use Green Gold. Dry with a hair dryer.

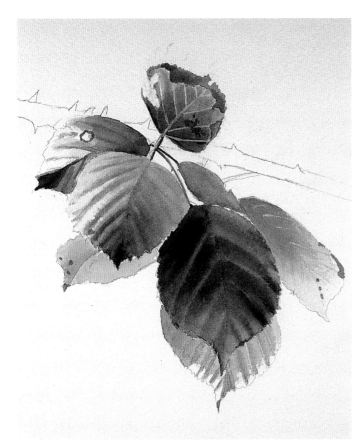

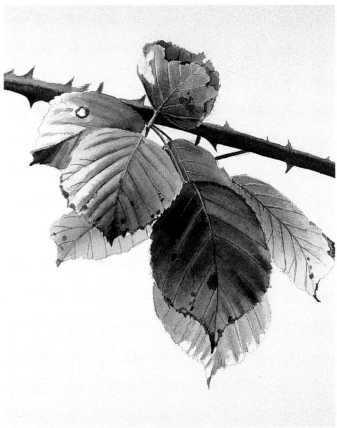

2 One leaf at a time, brush some additional Hooker's Green Dark into the darker shadow areas with the no. 4 round until the values are correct. Use a damp brush to pull the color out in the highlight areas.

3 Paint the blackberry cane with Burnt Sienna, pulling out toward the top highlight. Add some details, painting the veins with Hooker's Green Dark and adding some spots and edges of Burnt Sienna for interest.

Maple Leaves—Using Underwashes to Make Colors Glow

Sometimes even our brightest pigments can't quite match the vibrancy of flowers and fall leaves. Since nothing in nature is really just one color, you'll find that botanical subjects often look more realistic if you use underwashes of pale color.

MATERIALS LIST	Watercolors	Other
	Burnt Sienna	Arches 300-lb. (640gsm) cold-pressed paper
	Hansa Yellow Light	
	Organic Vermilion	Bar soap
	Payne's Gray	Facial tissues
		Hair dryer
	Brushes	Masking fluid
	Nos. 2, 4 and 6 rounds	No. 2 pencil
	Old no. 1 synthetic round	Old bath towel
		Palette
		Soft rags or paper towels
		Workable fixative

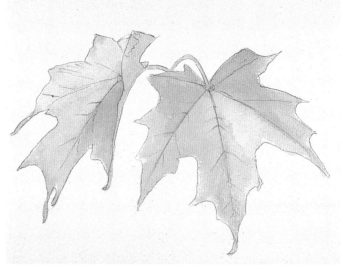

1 Create your line drawing and spray with workable fixative. Mask the larger veins.

Use the no. 6 round to wet each leaf and apply an underwash of Hansa Yellow Light, charging with Payne's Gray to indicate the shadow areas. Dry with a hair dryer.

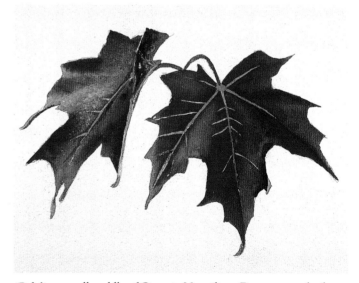

2 Mix a small puddle of Organic Vermilion. Dampen one leaf again. Paint this color over the yellow, varying the intensity so that the yellow shows through in some areas. Repeat with other shades of red and Burnt Sienna until you have built up the color value and intensity to your satisfaction.

Flare

Use your barely damp brush to control the amount of flare.

3 Use the no. 2 round to enhance the veins and dark spots with touches of Burnt Sienna. Use a damp no. 4 round to lift off a little color here and there to create highlights.

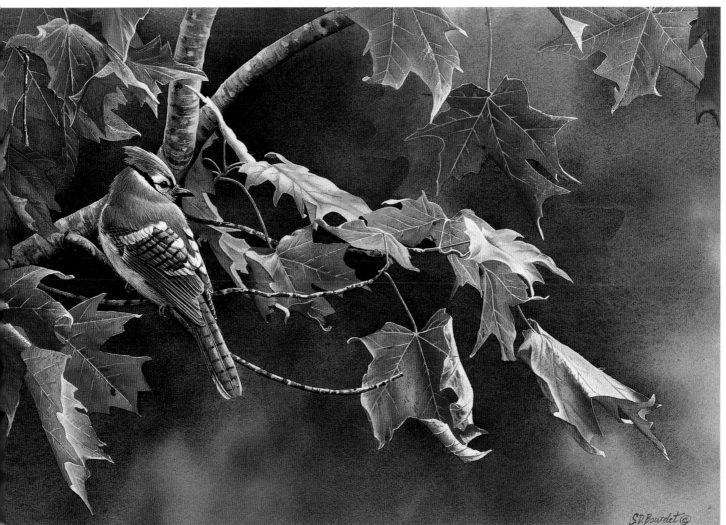

FALL PALETTE
Blue Jay
Watercolor on Arches 300-lb. (640gsm) cold-pressed paper
14" x 21" (36cm x 53cm)

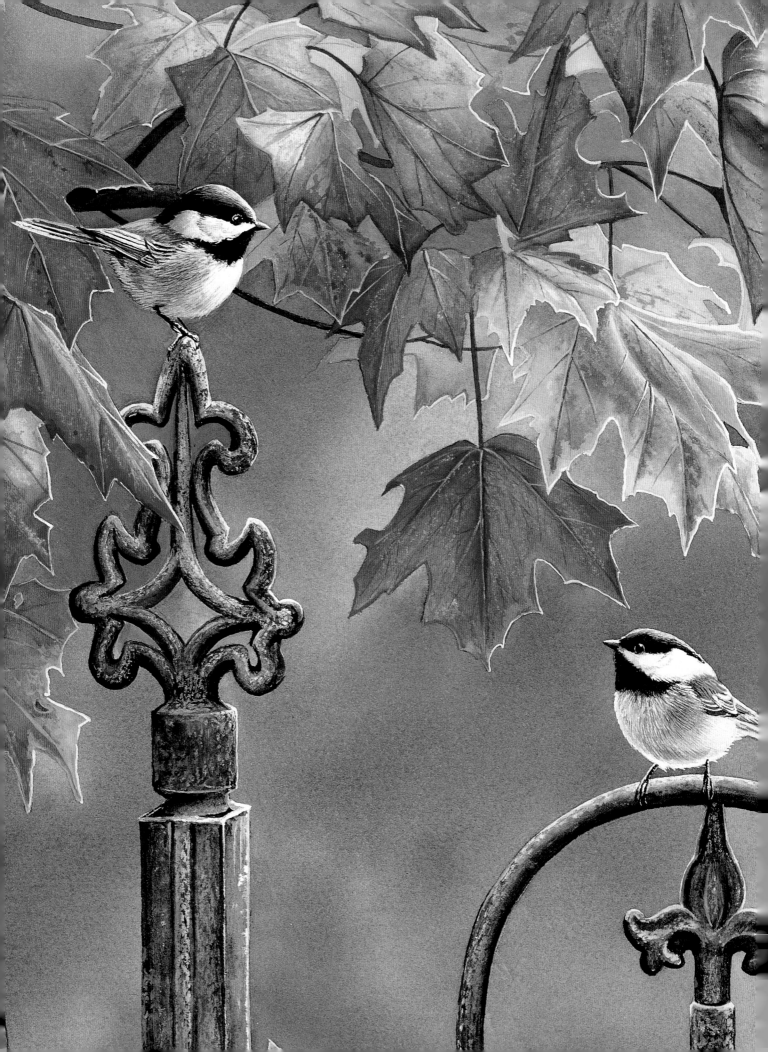

Painting Birds

areful observation is required to portray a living creature. The animal must be animated while still maintaining the correct anatomy. You can achieve lifelike poses by avoiding standard profiles and trying to capture some characteristic behavior and attitude. In this chapter, you will learn techniques for creating the basic avian form as well as methods for painting anatomical features and feather details.

VICTORIAN SEASONS—FALL
Black-Capped Chickadee
Watercolor on Arches 300-lb. (640gsm)
 cold-pressed paper
22" x 15" (56cm x 38cm)

Bird Anatomy

My paintings always seem unfinished to me without some element that can fly or dart from the page. Birds are my favorite subjects, and I feel that they give my paintings the living touch that makes them complete.

In order to paint them convincingly, you'll need to have a basic understanding of their anatomy. Bird books refer to field markings, distinguishing feather patterns and anatomical characteristics that help them identify their subjects. As artists, we'll note these too, as these are the features that distinguish one bird from another. In later demonstrations I will refer to the correct anatomical parts of the bird, so pay close attention.

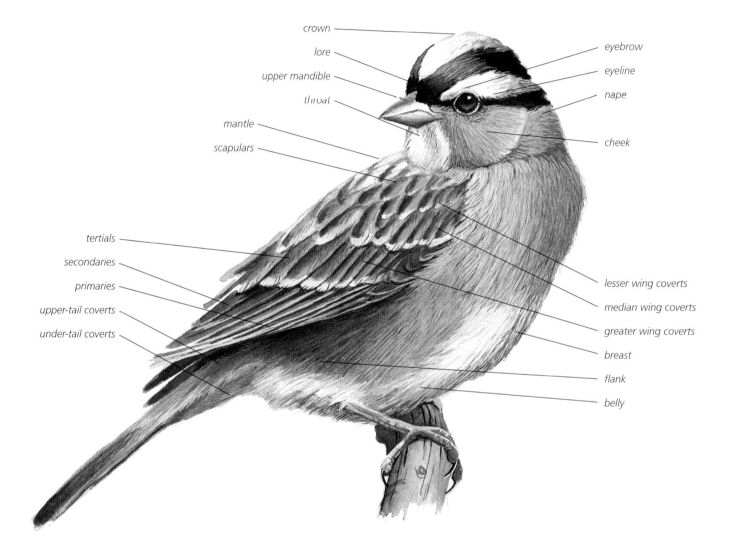

White-Crowned Sparrow

Painting Birds—Basic Techniques

The steps below will give you the general instruction for creating birds. This will be an outline for painting any type of bird.

1 Always begin with a line drawing, detailed enough so that all of the field markings are indicated and the anatomical information is accurate. Before you apply any color, you should also determine where the light is coming from and how the highlights and shadows will define the bird's form.

2 The next step is to paint the basic color areas. At this stage you will begin to establish the round form by carefully pulling out each wash toward the highlight areas. Notice that in this early phase, the values are all light.

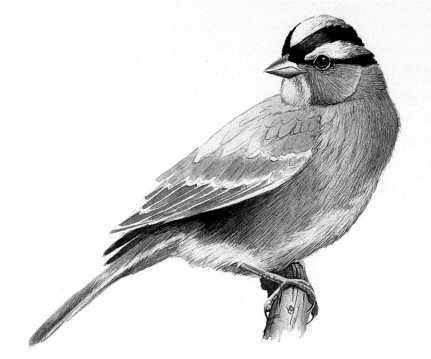

3 When the first washes are dry, add another wash layer, starting the application in the most shadowed areas and pulling out toward the highlights again. This time the colors should be a little darker, but should be pulled out so that they don't entirely cover the previously painted areas. This adds more roundness to the form. One layer at a time, more color is added to the shadow areas, like the underside of the belly and under the wing. Each shadow is then pulled out until the shape looks three-dimensional.

4 Feather groups are delineated by painting the shadows under them. Fine line details are added last.

| # Painting Beaks

Beaks vary considerably with habitat and diet. The pulling-out and building-up approaches work well for all types of beaks. As with the rest of the body, look at the light source and determine where the highlights will be, then draw carefully so that the mouth-line and nostril are located.

MATERIALS LIST	Watercolors	Other
	Burnt Sienna	Arches 300-lb. (640gsm) cold-pressed paper
	Hansa Yellow Light	Facial tissues
	Payne's Gray	Hair dryer
	Quinacridone Pink	No. 2 pencil
		Palette
	Brushes	Soft rags or paper towels
	No. 1 or 2 round	

1 Paint strokes of a Burnt Sienna and Quinacridone Pink mix along each mandible with a no. 1 or 2 round. Use the rinsed damp brush to carefully pull out these little washes, softening toward the highlights. Dry with the hair dryer.

2 Use Payne's Gray mixed with Burnt Sienna to paint the mouth-line. Notice that the mouth-line is not straight but curves up and then down where the mandibles join. This curve is more dramatic on seedeaters like this sparrow, while birds that eat insects need less leverage and have a straighter mouth. Use a slightly grayer mixture to build up the washes along each mandible, pulling out to make a soft blend.

3 Pay careful attention to the direction of feather growth around the lore and chin as you indicate these delicate feathers with fine lines of Burnt Sienna. Paint the eyebrow with Hansa Yellow Light.

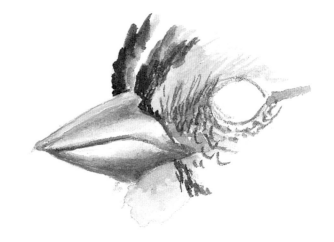

Painting Eyes

Eye shapes vary also, and will sometimes be distinguished by a definite ring of feathers. The eyelid is a tiny edge of little scales around the outer rim of the eye. In some kinds of light, you will see the brown iris but in many cases, especially when the bird is small in your composition, the eye will just look black. Very essential is the tiny highlight—without that the eye looks dead.

MATERIALS LIST	Watercolors	Other
	Burnt Sienna	Arches 300-lb. (640gsm) cold-pressed paper
	Payne's Gray	Facial tissues
	Brushes	Hair dryer
	No. 1 or 2 round	No. 2 pencil
		Palette
		Soft rags or paper towels

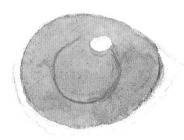

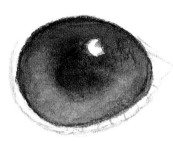

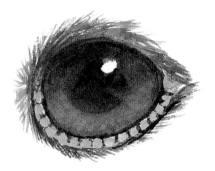

1 Paint the brown part of the eye with Burnt Sienna first, avoiding the highlight. Dry with a hair dryer. The highlight should be placed along the edge of the dark pupil, never too near the center of the eye.

2 Next, paint the black pupil with a dark value of Payne's Gray. Around the inside rim of the eye, paint a dark line of Payne's Gray, then soften the upper half of this line, pulling out to make a shadow for the upper lid. Continue to avoid the highlight.

3 Dilute the same mix to paint the fine scales and feathers around the eyelid.

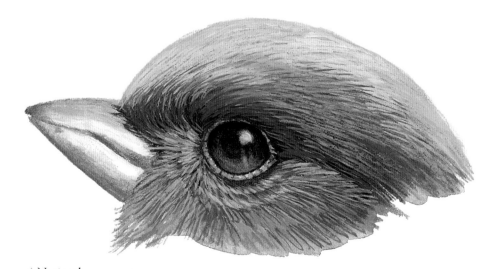

4 Notice the pattern of feather growth as you paint the eyebrow and eye patch.

Painting Feet and Legs

Feet and legs can be a source of frustration for artists, because they are difficult to see and, like beaks, vary widely in form and color. Notice that the foot is designed for gripping, with cushioned toe pads and a longer middle front toe that works with the back toe to hold firmly onto the perch. Here we can see the bird's relationship to reptiles—the legs and feet are scaly rather than smooth.

| MATERIALS LIST | **Watercolors**
Payne's Gray
Quinacridone Sienna

Brushes
No. 1 or 2 round | **Other**
Arches 300-lb. (640gsm) cold-pressed paper
Facial tissues
Hair dryer
No. 2 pencil
Palette
Soft rags or paper towels |

Feet
Use a darker mix of Payne's Gray and Quinacridone Sienna to designate the scales on the legs and feet. Notice the pattern of these scales; it is similar on most birds. Use dark gray to add final details. Use a nearly black mix of Payne's Gray for the claws, leaving a slight highlight.

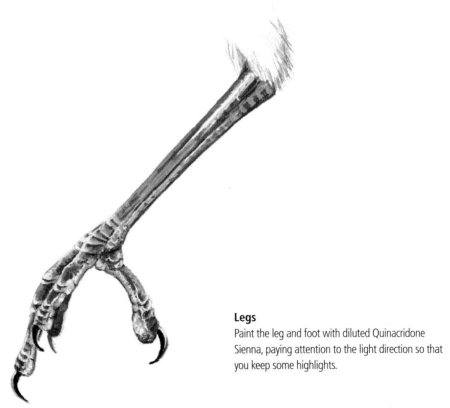

Legs
Paint the leg and foot with diluted Quinacridone Sienna, paying attention to the light direction so that you keep some highlights.

Pileated Woodpecker

Now we'll employ several of the techniques we've learned. This pileated woodpecker's distinguishing field markings are his large size, his red cap and the pattern of his white plumage.

<table>
<tr><td rowspan="2">MATERIALS
LIST</td><td>Watercolors</td><td>Other</td></tr>
<tr><td>Burnt Sienna

Payne's Gray

Permanent White
Gouache

Quinacridone Gold

Quinacridone Red

Quinacridone Sienna

Brushes
Nos. 1, 2, 4 and 8 rounds

1-inch (25mm) flat

Old no.1 synthetic round</td><td>Arches 300-lb. (640gsm)
cold-pressed paper

Bar soap

Facial tissues

Hair Dryer

Masking fluid

No. 2 pencil

Palette

Soft rags or paper towels

Tracing paper</td></tr>
</table>

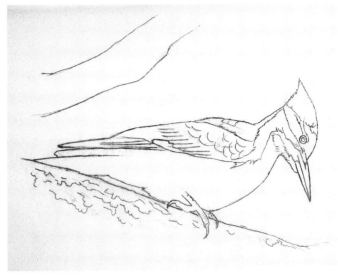

1 Draw the bird and tree, sketching in field markings and anatomical details. Use tracing paper to transfer your drawing onto the watercolor paper.

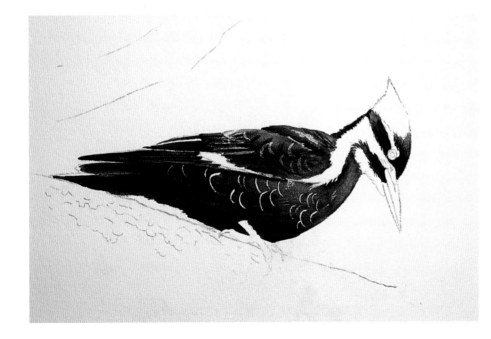

2 Use the no. 1 synthetic round to mask a few half-circle lines on the breast, belly and wing coverts. Allow to dry. Using the no. 4 round, paint the breast, belly, throat and black facial stripes with Payne's Gray. On the breast and belly, make the color dark at the bird's front and pull out to give roundness. Dry with a hair dryer.

Paint each wing section by applying dark color to the lower edge and pulling out toward the highlight along the bird's back. While each wash is still a little wet, add a few strokes to suggest feather shapes. Dry, then remove mask.

3 Glaze the breast, belly and wing coverts with diluted Burnt Sienna to soften the masked lines.

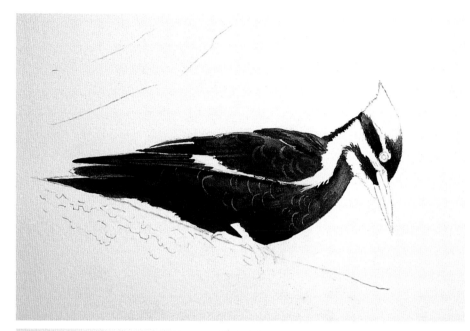

4 Using the no. 2 round, paint the red cap with Quinacridone Red, using fine feather lines to blend the color into the rest of the head. On the light area in front of the cap, paint some lines of diluted Burnt Sienna.

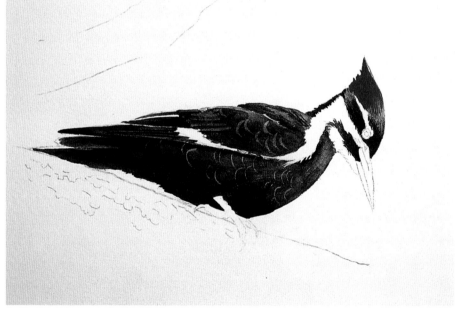

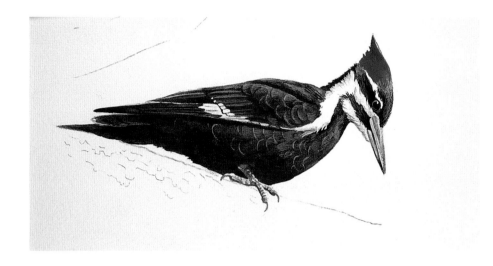

5 Use the no. 1 or 2 round to paint the iris of the eye with Quinacridone Sienna and the pupil with Payne's Gray, conserving the highlight. Blend to shade the upper edge and right side of the iris. Paint the beak with diluted gray, keeping the top edge white. Dry with the hair dryer.

Paint the mouth-line, the nostril and the tip of the lower mandible with darker gray. Add a touch of diluted sienna to the lore. Paint the foot with diluted gray, then dry and add the scales with a darker mix. Dry again, then paint the claws and the shadow detail on the undersides of the toes. Mix some diluted gray and add feather details to the white markings. Use thinned Permanent White gouache to add fine feather lines to the highlight areas on the back, wing coverts and breast.

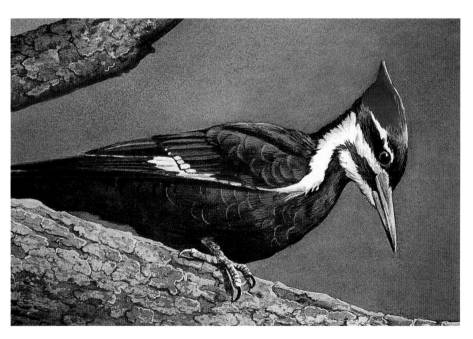

6 Complete the study using the 1-inch (25mm) flat to paint the background with a mixture of Quinacridone Gold and Payne's Gray, working quickly around the bird shape. Dry with the hair dryer.

Use the no. 8 round to drybrush the bark texture. Mix a dark wash of Payne's Gray and Burnt Sienna and apply it to the tree branch and the right side of the trunk, pulling out toward the brighter left side. Dry with the hair dryer.

Use the no. 1 or 2 round to add some line detail and the shadow of the foot.

Rufus Hummingbird

The amazing thing about hummingbirds is their incredibly fast motion. To capture that effect, the wings can't appear to be stiffly frozen in position. In this study, we'll use gouache to paint the wings, creating a translucent effect that suggests movement.

MATERIALS LIST		
Watercolors	**Other**	
Burnt Sienna	Arches 300-lb. (640gsm) cold-pressed paper	
Green Gold	Bar soap	
Hansa Yellow Light	Facial tissues	
Hooker's Green Dark	Hair dryer	
Payne's Gray	Masking fluid	
Permanent White gouache	No. 2 pencil	
Quinacridone Pink	Old bath towel	
Quinacridone Red	Palette	
Quinacridone Sienna	Soft rags or paper towels	
	Water-filled spray bottle	
Brushes		
Nos. 1 and 3 rounds		
1½-inch (38mm) flat		
Old no. 2 synthetic round		

1 Draw and mask. Using the 1½-inch (38mm) flat, do a wet-into-wet wash of Payne's Gray and Hooker's Green Dark on the background area. Dry with a hair dryer.

2 For the hummingbird, use the no. 3 round and the lightest shades of Quinacridone Sienna and Green Gold, pulling out to the highlights at the crown and back. Build up these washes to give form and dimension to the bird's body.

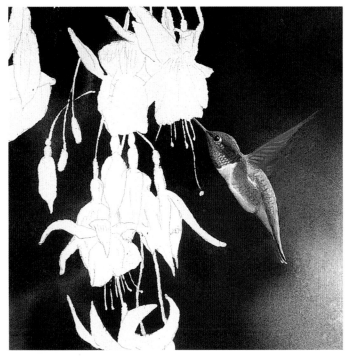

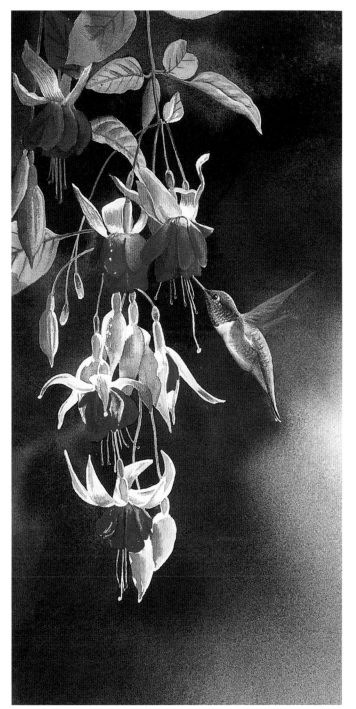

3 Paint the wings with Permanent White gouache, using the no. 3 round. Thin the gouache to a milky consistency and begin nearest the body, pulling out to the wing-tip. If the wing looks too pale when dry, add a second coat, again pulling out to the tip of the wing. Soften the edges with a damp brush once the gouache has dried to create a blurry effect. Use the no. 1 round to paint the eye with Payne's Gray, conserving a tiny highlight and a small white patch at the outer corner.

4 Paint the fuchsias with Quinacridone Pink, Quinacridone Red and Burnt Sienna, using the pulling-out and building-up techniques and the no. 3 round. For the leaves, use Green Gold as a base wash, then charge with Hooker's Green Dark. Detail the veins with Quinacridone Red and the no. 1 round. Lift out highlights if needed.

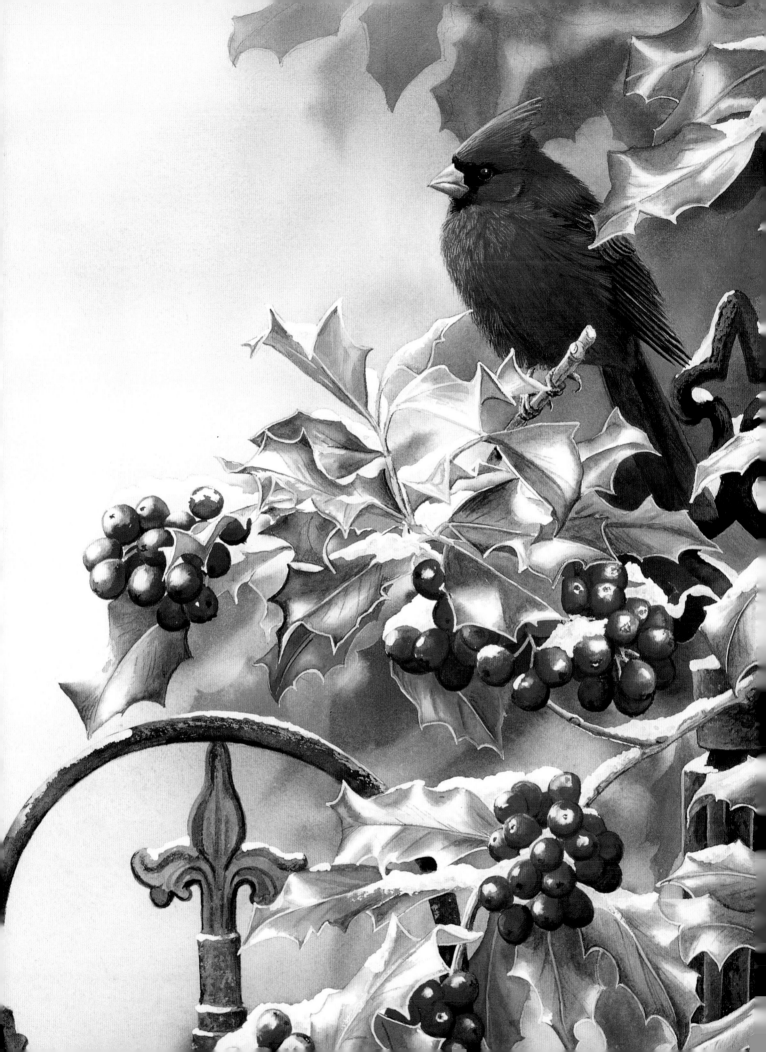

Painting Nature's Textures

Believable nature paintings begin with a good idea and a good understanding of watercolor as a medium. We've studied how to use basic watercolor techniques like wet-into-wet and wet-on-dry to execute those ideas. Now we can progress to the next level of complexity—the surface detail and texture that capture the essence of each subject. Often beginning painters have trouble capturing texture because they use a small brush—one better suited for detail work—to paint a lot of small lines and shapes. In the process they simply paint over the beauty and freshness of their washes with a lot of little lines. The trick is to take full advantage of watercolor's strengths as a medium—to suggest, rather than paint—the surface character of the subject.

VICTORIAN SEASONS—WINTER
Northern Cardinal
Watercolor on Arches 300-lb. (640gsm)
 cold-pressed paper
21" x 15" (53cm x 38cm)

Painting Surfaces—Basic Techniques

There are five basic techniques I use in nearly all of my paintings to capture surface textures: drybrush, scratching out, rock and/or table salt, masking fluid spatter and spatter.

Drybrush
Drybrush is accomplished by dragging the brush, loaded with paint and very little water, over the dry paper. It can be used by itself, over or under a wash. The effect will vary greatly depending on the kind of brush you use, the stroke direction and texture of the paper.

Scratching Out
Great for adding fine white lines like cobwebs: this works best on dark washes. Scratching must be done carefully because it damages the paper surface and can't be reversed.

Rock Salt
Rock salt creates large crystal shapes.

Table Salt
Salt can be sprinkled into a wet or damp wash to create an interesting crystalline pattern.

Masking Fluid Spatter
For very white, crisp dot patterns, you can spatter masking fluid with a toothbrush or a round synthetic brush. In order to cover the whole painting surface as in the case of falling snow, the mask needs to be applied to the drawing before you begin to paint.

Spatter
Any color can be spattered, and the kind of pattern depends on the tool—round brush, flat or toothbrush. Spatter can be applied over a dry wash for texture or into a damp wash to create random soft-edged spots.

Weathered Wood—Drybrush Technique

Weathered wood is an ideal subject for the drybrush technique. These textures were created on Arches 300-lb. (640gsm) cold-pressed paper. They can be varied by changing the amount of water or type of brush used, or by using rougher paper. There are an infinite number of variations you can produce with the drybrush technique.

Example 1
This example was done using a 2-inch (51mm) hake with Payne's Gray, Burnt Sienna and very little water.

Example 2
This example was done using a 2-inch (51mm) hake with Payne's Gray and Burnt Sienna. Place a little water on the brush and fan out the bristles with your fingers before painting.

Old Fence—Drybrush Technique

Here the drybrush technique is used for an old fence. Drybrush the texture on, then dry, gradually building up with more layers of drybrush to the desired value and roughness. Details and shadow washes can be painted or glazed on top of the texture as long as the texture is not completely covered. You can take advantage of the unintentional patterns created by drybrushing to add cracks, splits and grain patterns. To add interest, you can also spatter over top of the drybrush strokes to give the appearance of wormholes or termite damage.

<table>
<tr><td rowspan="2">MATERIALS
LIST</td><td>**Watercolors**</td><td>**Other**</td></tr>
<tr><td>Burnt Sienna
Cobalt Blue
Payne's Gray
Permanent White gouache
Quinacridone Gold

Brushes
1-inch (25mm) flat
Nos. 2 and 8 rounds</td><td>Arches 300-lb. (640gsm) cold-pressed paper
Facial tissues
Hair dryer
No. 2 pencil
Old soft and hard toothbrushes
Palette
Soft rags or paper towels</td></tr>
</table>

1 Load half of the 1-inch (25mm) flat with Burnt Sienna and the other half with Payne's Gray. Drag the brush in the direction of the wood grain. You can achieve some interesting streaks and variations by loading the brush this way. Dry with a hair dryer.

2 Using the no. 8 round, continue to drybrush the wood using the same colors but add less water to create more texture. Darken the shadow areas with drybrush strokes of Payne's Gray.

3 Use the no. 8 round to glaze the shadow areas with a mix of Payne's Gray and Cobalt Blue. Dry. Use the no. 2 round to paint a few cracks and splits in the wood.

Tip
Transparent Washes

Transparent washes can either be applied before the texture or lightly glazed over the drybrush strokes. I often glaze over the texture to add shadows and cool tones in the background parts of the structure, or to add warm tones to the foreground.

4 Drybrush a little Quinacridone Gold here and there with the no. 8 round. Use the no. 2 round and a touch of Permanent White gouache to emphasize the light edges of the cracks and to paint a few lichen patches.

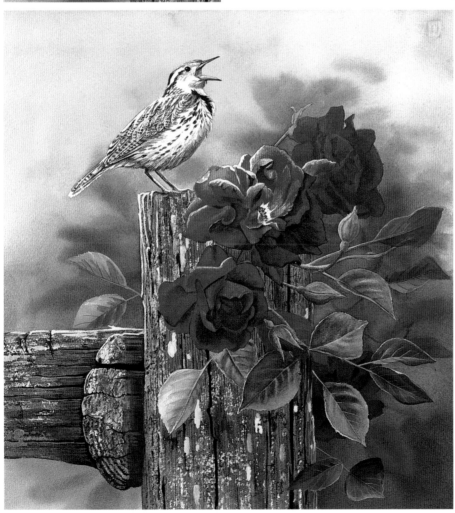

SUMMER SONG
Meadowlark
Watercolor on Arches 300-lb. (640gsm)
 cold-pressed paper
14" x 15" (36cm x 38cm)

Cobwebs—Scratching-Out Technique

To create the cobwebs, the finishing touch for this painting, carefully scratch them out with a very sharp craft knife. Once the scratching process is finished, you can drybrush just a little Permanent White gouache over the thicker cobweb areas to soften them.

MATERIALS LIST	Watercolors	Other
	Watercolors Permanent White gouache	**Other** Arches 300-lb. (640gsm) cold-pressed paper
	Brushes No. 4 round	Craft knife Facial tissues Palette Soft rags or paper towels

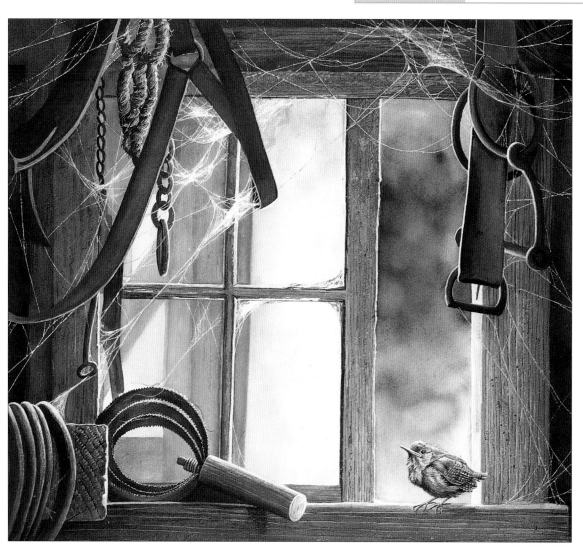

TACKROOM WREN
House Wren
Watercolor on Arches
300-lb. (640gsm)
cold-pressed paper
17" x 15" (43cm x 38cm)

Rock Texture—Salt Technique

In addition to drybrush and spatter, I often use the salt technique to reproduce the textures of rocks. Salt creates an interesting crystalline pattern in watercolor pigments because the color is pulled into the salt grains as the pigment dries. Salt textures work best when allowed to air-dry naturally. The effect will vary depending on how wet the color is when you add the salt. For a small, delicate crystal shape, sprinkle table salt on the wash as the shine leaves the paper. Applying the salt while the wash is slightly wetter can create a larger blotchy effect that looks like lichen patches. For extra large crystal shapes, you can carefully place rock salt crystals on the paper instead of table salt. The salt technique should be practiced before you use it in a painting, because the effect will be more pronounced with some pigments than with others. You'll also find that humidity can change the results, so doing a test swatch is a good idea.

MATERIALS LIST	Watercolors	Other
	Burnt Sienna	Arches 300-lb. (640gsm) cold-pressed paper
	Naples Yellow	Bar soap
	Payne's Gray	Hair dryer
	Quinacridone Gold	Masking fluid
	Ultramarine Blue	No. 2 pencil
	Brushes	Old soft and hard toothbrushes
	Nos. 2, 4 and 10 rounds	Soft rags or paper towels
	2-inch (51mm) hake	Table and/or rock salt
	Old no. 2 synthetic round	

1 Draw the composition on watercolor paper. Mask the twigs and leaves with the no. 2 synthetic round. Mix puddles of Payne's Gray, Ultramarine Blue and Burnt Sienna. Using a no. 10 round, drybrush the two larger background rocks with a mix of Payne's Gray and Burnt Sienna, leaving a bright patch at the top of the left-hand rock. Use the no. 4 round to paint the dark spaces between the rocks with a dark mix of Payne's Gray and Burnt Sienna. Dry with a hair dryer. Using the 2-inch (51mm) hake, glaze over the dark background rock with a combination of Payne's Gray and Ultramarine Blue.

2 Wet the foreground rocks one at a time. Use the no. 10 round to paint the soft-edged shadows with a mix of Payne's Gray and Ultramarine Blue. While still wet, paint the darkest area (where the rock meets the ground) with a dark mix of Payne's Gray and Burnt Sienna, pulling up to make a rounded form. As the shine is just leaving each wash, sprinkle a pinch of table salt over the area. Air dry until the crystal pattern has developed, then blow dry to remove excess salt. Paint the cast leaf shadows with the blue-gray mix, softening the edges on the rock at the lower right. Dry with a hair dryer.

3 Drybrush each rock with a light mixture of the Payne's Gray, Ultramarine Blue and Burnt Sienna, leaving most of the crystal pattern uncovered. Spatter a little with darker mixes of the same colors, again using the no. 10 round. Paint the leaves with Quinacridone Gold, Burnt Sienna and Naples Yellow, using the no. 4 round.

Using the no. 10 round, deepen the shadows and spaces between rocks with a mix of Payne's Gray and Ultramarine Blue. Dry with a hair dryer. Remove the mask.

4 Shade the undersides of the twigs with a mix of Payne's Gray and Burnt Sienna and add a few lichen patches in the same color.

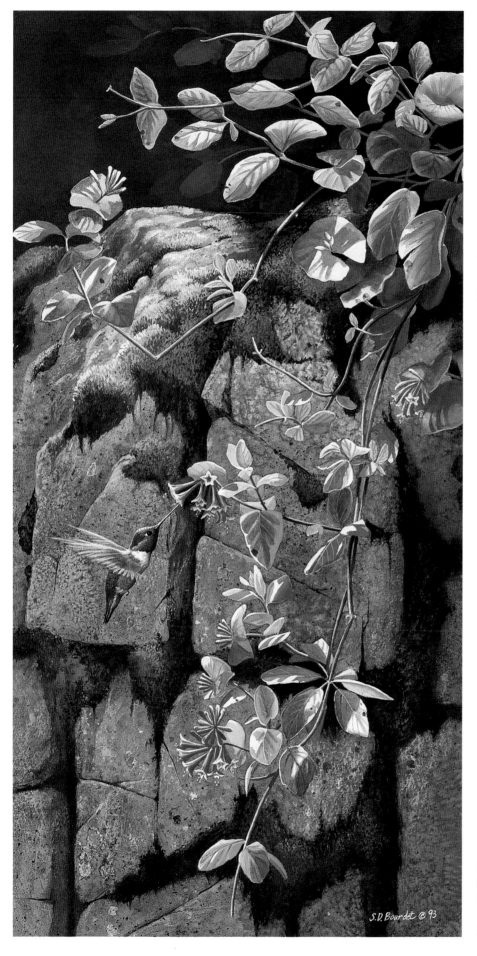

OVER THE WALL
Rufus Hummingbird
Watercolor on Arches 300-lb. (640gsm) cold-pressed
　　paper
20" x 15" (51cm x 38cm)

Bark, Moss and Lichen—Various Techniques

The textures of bark, moss and lichen add realism to paintings of old wooden structures and branches. To create these textures, you'll need to examine your subject very closely. Minute though they are, these tiny plants have an intricate structure. I used a combination of wet-into-wet underwashes, drybrush, masking and *negative painting* for the lichens on this branch. Negative painting is the process of defining shapes by painting the spaces behind them, making the shapes appear to stand out from a dark background.

MATERIALS LIST		
Watercolors		**Other**
Burnt Sienna		Arches-300-lb. (640gsm)
Cobalt Blue		cold-pressed paper
Payne's Gray		Facial tissues
Quinacridone Gold		Hair dryer
		Masking fluid
Brushes		No. 2 pencil
Nos. 2, 4 and 10 rounds		Old bath towel
Old no. 2 synthetic round		Palette
		Soft rags or paper
		towels

1 Draw the branch. Use the no. 2 synthetic round to paint the masking fluid in little squiggles to represent the lichens. Mix puddles of Payne's Gray, Cobalt Blue and Quinacridone Gold. Wet the upper part of the background with water using the no. 10 round, then paint that portion of the background. Paint about one-third of it with a dark-blue mix made of Cobalt Blue and Payne's Gray. Rinse the brush, change to the gold and then go back to the blue mixture. Leave some areas nearly white so the light will appear to come through the trees. Tilt the paper to achieve soft blends. Repeat for the lower part of the background. As the shine leaves these washes, paint in dark streaks of gray to represent the background mosses. Dry with a hair dryer. Drybrush a little Burnt Sienna on the branch.

2 Use the no. 4 round to build up the drybrush strokes on the upper half of the branch, alternating between Payne's Gray and Burnt Sienna to create bark-like patches. Don't dry between applications— allow the colors to blend a little. Work down to the lower-half of the branch and the hanging mosses with a very dark mix of sienna and gray, making the ends of the mosses ragged and thready.

3 Remove the mask. Create a pale graygreen mixture using Payne's Gray and Quinacridone Gold to paint the lichens. Dry with a hair dryer.

Use the no. 2 round to define the lichen shapes by negative painting with Payne's Gray. Paint in a few more background mosses with the no. 4 round, softening them with a damp brush.

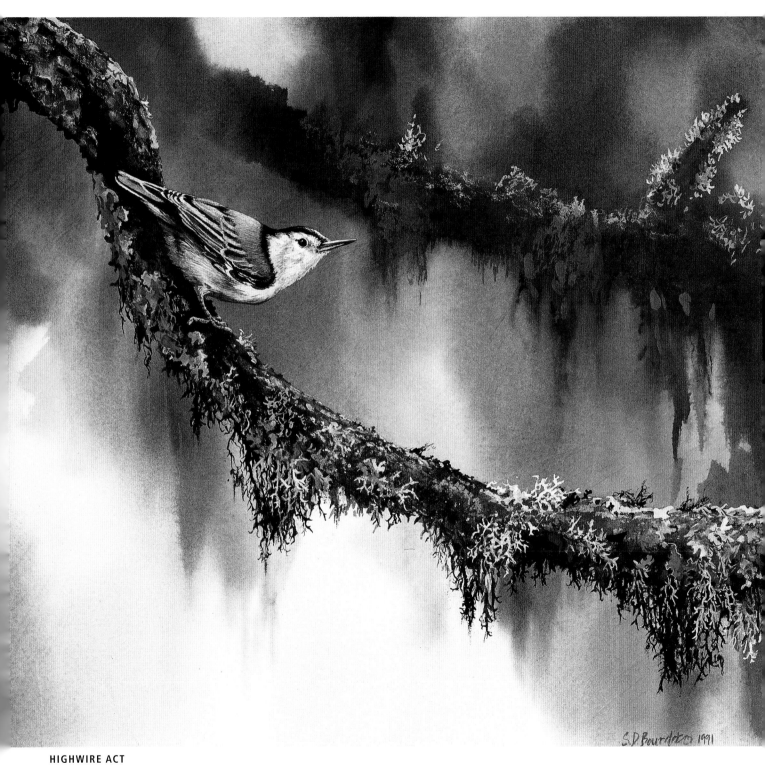

HIGHWIRE ACT
White-Breasted Nuthatch
Watercolor on 140-lb. (300gsm) cold-pressed paper
13" x 15" (33cm x 38cm)

Weather Effects, Snow—Salt and Spatter Techniques

For seasonal paintings we need some methods for suggesting the effects of weather—most commonly snow and fog. For falling snow, there are three techniques that do a good job of suggesting flakes.

Salt

The snowflake size depends on how wet the paper is when salted. Very wet paper, before the shine goes off, makes a larger flake, sometimes swirling like a blizzard. Drier paper, just after the shine goes off, makes a tiny, crystalline flake. Salt must be applied to wet paper.

Masking Fluid Spatter

Spattering masking fluid produces a very white flake, usually round in shape. This effect must be applied before any washes or objects are painted.

Gouache Spatter With Toothbrush

When gouache is spattered with a toothbrush it produces a similar effect to the masking fluid, but not quite as white. Spatter can be used over a finished dry wash; or over a slightly damp wash for a softer effect. Avoid spattering over a painted foreground—it's safer to paint in these flakes with a detail brush.

Painting Snow—Spatter Techniques

To give this snowy scene depth, I needed snowflakes of varying size and whiteness. I used a combination of the gouache and masking fluid spatter techniques to make the foreground snowflakes, which were masked, appear to be whiter and larger than the background ones, which were spattered. This gives a feeling of depth.

MATERIALS LIST		
Watercolor		**Other**
Cobalt Blue		Hair dryer
Naples Yellow		Masking fluid
Oxide of Chromium		No. 2 pencil
Payne's Gray		Palette
Permanent White gouache		Soft rags or paper towels
Quinacridone Red		Water-filled spray bottle
Ultramarine Blue		
Brushes		
2-inch (51mm) hake		
Nos. 2 and 4 rounds		
Old no. 2 synthetic round		
Old soft and hard toothbrushes		

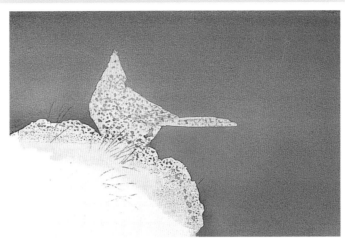

1 Draw and mask the center of interest. Also mask a few larger snowflakes in the background with the no. 2 synthetic round, spacing them randomly. Use the 2-inch (51mm) hake to paint the background with a wash of Payne's Gray in a medium value. Dry with a hair dryer.

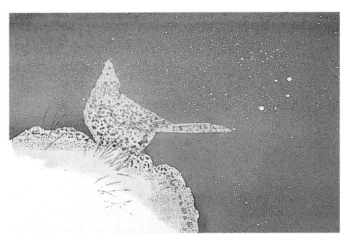

2 Before removing the masking fluid, cover exposed unmasked areas of the painting with paper towels. Squirt some Permanent White gouache on the palette, dip a toothbrush in water and then load it with white, mixing to a uniform thick cream consistency. Practice spattering on another paper, adding a little more water or paint until the consistency is right. The spatters should be thick enough to cover, but not so thick that they make gobs on the paper. When you've got it right, spatter the entire background of the painting. Dry with the hair dryer until all spatters are dry.

Tip

The Right Toothbrush

The toothbrush you use is important! Often the very soft ones make spatters that are too uniform and tiny, where the harder-bristled ones give the more randomly sized spatters you want. Try several to get the right look.

3 Remove the masking fluid. Use the no. 2 synthetic round to mask a few snowflakes on the cardinal, especially along his back. Mask a few additional flakes in the foreground branches and at the tips of some of the pine needles.

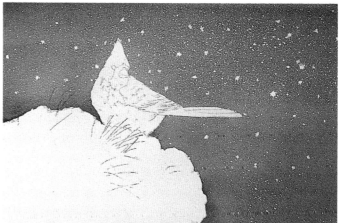

4 Use the no. 4 round to paint the shadow areas of the snowy pine branch with gray, pulling out for soft edges. Dry with a hair dryer.

5 Use the nos. 2 and 4 rounds with Quinacridone Red to paint the cardinal, pulling out to create highlights at the left side of the crest, the back and the top of the tail. Shade with a second wash, using a dark mixture of Payne's Gray with the red, and pulling out toward the brighter areas. Paint the eye, mask with Payne's Gray and use the gray-red mixture to add feather details. Paint the pine needles with a mix of gray and Oxide of Chromium. Dry with a hair dryer. Remove the masking fluid.

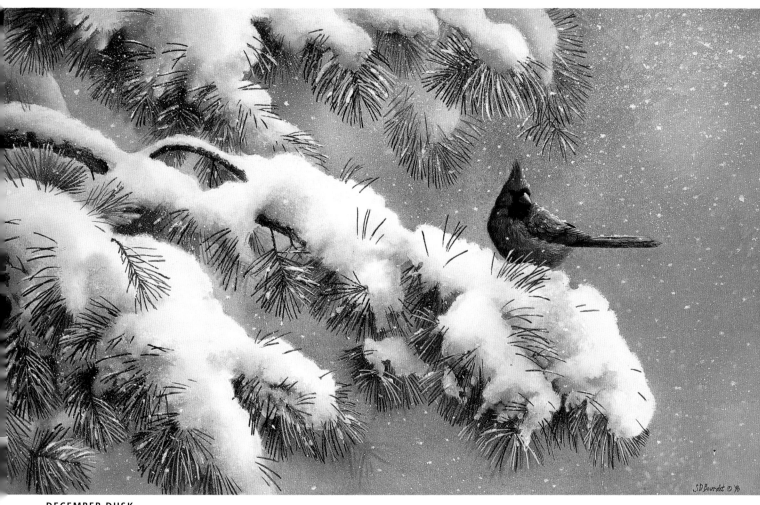

DECEMBER DUSK
Northern Cardinal
Watercolor on Arches 300-lb. (640gsm) cold-pressed paper
13" x 19" (33cm x 48cm)

Tip
Painting Snow

To make snowy branches look realistic, apply the masking fluid so that the edges are ragged. For a rounded effect, shade the snow with cool tones like Payne's Gray, Ultramarine Blue, Cobalt Blue and subtle violet blends created by mixing Payne's Gray and a little Quinacridone Red. Where sunlight hits the snow, the whiteness will be warmed slightly—apply a light wash of Naples Yellow to add a little warmth. Use the wet-into-wet method and pull out, blend and create soft edges. Drybrush here and there to create lacy dark edges against the light areas. Twigs and branches will show through the snow and be coated with frost and ice, which can be suggested by drybrushing with Permanent White gouache.

Weather Effects, Fog—Wet-Into-Wet Technique

Fog is best suggested by using the wet-into-wet method. If you look at the landscape on a foggy day, you will notice that more distant shapes will be muted tints and tones of the foreground colors. To suggest the coolness of fog, you can make the distant colors cooler and use the soft-focus effect of wet-into-wet to make them appear hazy. The hazy effect is enhanced by applying a light coat of white gouache to the paper before doing the wash.

MATERIALS LIST		
Watercolors	**Other**	
Burnt Sienna	Arches 300-lb. (640gsm) cold-pressed paper	
Hansa Yellow Deep		
Hansa Yellow Light	Bar soap	
Naples Yellow	Craft knife	
Payne's Gray	Facial tissues	
Permanent White gouache	Masking fluid	
	No. 2 pencil	
Ultramarine Blue	Hair dryer	
	Old bath towel	
Brushes	Palette	
Nos. 2, 4 and 10 rounds	Soft rags or paper towels	
2-inch (51mm) hake		
No. 2 round synthetic	Water-filled spray bottle	

1 Draw and mask your painting. Mix puddles of Permanent White gouache, Payne's Gray, Burnt Sienna and Ultramarine Blue. Wet the entire painting surface with water, then use the 2-inch (51mm) hake to coat the background with a light undercoat of Permanent White gouache. Rinse the hake and reload with a dark mix of Payne's Gray and Ultramarine Blue. Brush this into the background behind the bird and the reeds, brushing it out to a light value as you work over to the right side of the painting. Change to the no. 10 round and suggest some reed shapes in the background, varying the colors with mixtures of gray, blue and sienna. These colors will be blurred and softened by the wet gouache coating on the paper. Dry with a hair dryer.

2 Use the no. 10 round to paint a few more background reeds over the dry wash, using tints of Payne's Gray and Burnt Sienna. These reeds will have a hard edge since the paper is dry, but will appear to be in the middle distance because of the softer color tints. Dry and remove the mask.

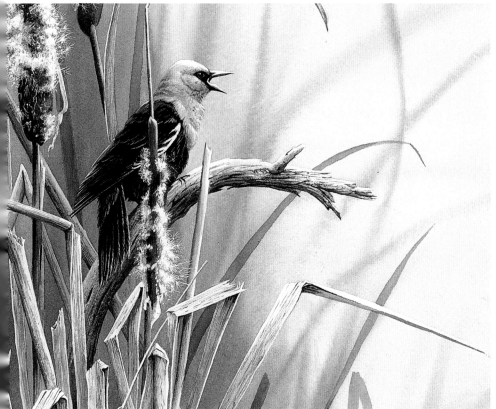

3 Paint the foreground elements, using the nos. 2 and 4 rounds. For the blackbird, paint the head and breast with Hansa Yellow Light and shade with Hansa Yellow Deep and Burnt Sienna. Paint the black feathers, legs and eye with dark Payne's Gray, conserving a highlight in the eye and pulling out to the highlights along the back. Paint the reeds with Naples Yellow and detail with Burnt Sienna. Shade the undersides with diluted Payne's Gray. For the foreground, you'll use each color at its full intensity instead of mixing a tint.

FOGGY DAWN
Yellow-Headed Blackbird
Watercolor on Arches 300-lb. (640gsm) cold-pressed
 paper
18" x 14" (46cm x 36cm)

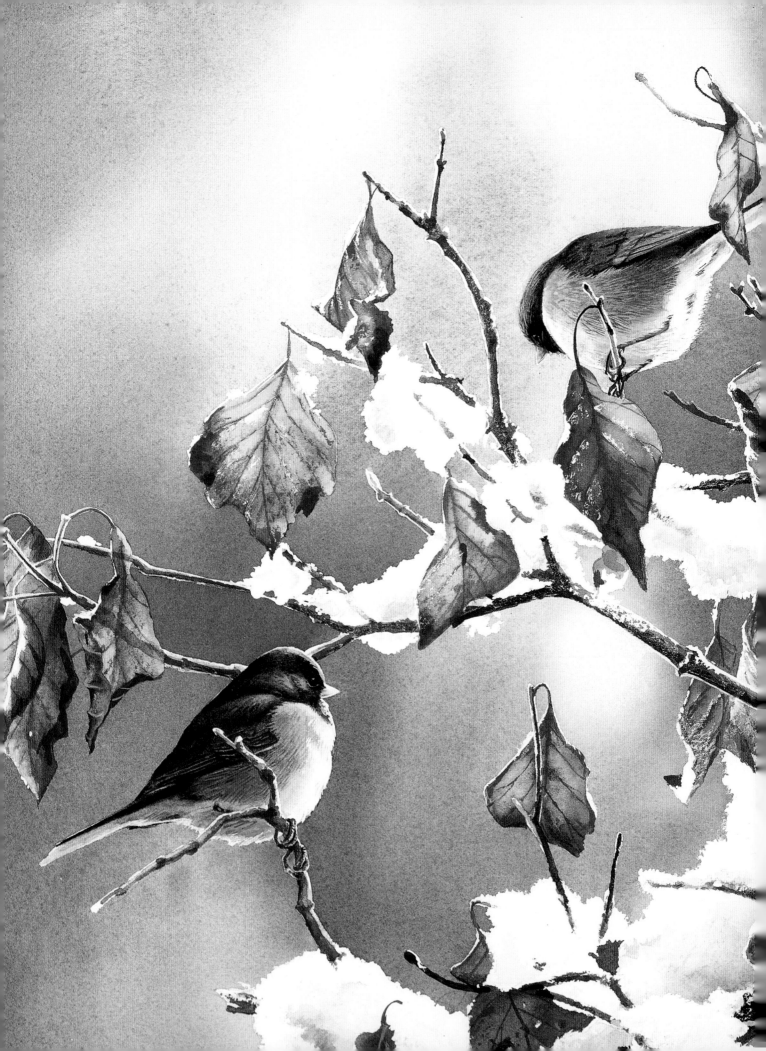

Putting it All Together, Step by Step

I n this chapter you'll see, one step at a time, how to create four different songbird paintings inspired by the seasons. The first, *Spring Lilacs—Goldfinches*, is a floral composition in which the sunlit foreground elements and pastel tones set the mood. The next project is *Vineyard Sentinel—Bluebird*, a painting in which the wet-into-wet background creates the effects of weather and light. In the autumn project, *Autumn Splendor—Blue Jay*, you'll practice the textures of old wood and peeling paint. We'll end the year with *Winter Perch—Cardinals*, which features the delicate, fluffy texture of a new snowfall.

WINTER LIGHT
Dark-Eyed Junco
Watercolor on Arches 300-lb. (640gsm) cold-pressed paper
15" x 12" (38cm x 31cm)

Spring Lilacs—Goldfinches

I grew up in the northwestern United States, where spring was often a long time coming. Imprisoned by winter snow, I waited and waited for spring, and knew that the season had finally arrived when the lilacs burst into bloom. Their fragrance, often mingled with the scent of rain, ushered in the long, carefree summer. When I smell lilacs now, I feel that same joyful anticipation. This painting has a nostalgic feel because of the old picket fence and the old-fashioned flowers. You'll use many of the foreground and texture techniques here, especially negative painting, which gives realism to the lilac clusters. Transparent colors like yellows are easily muddied, so you'll need to use clean water, palette and brushes. You'll also use your glazing techniques, drying between coats, to keep the colors pure.

MATERIALS LIST	**Watercolors**	**Other**
	Burnt Sienna	Arches 300-lb. (640gsm) cold-pressed paper, 22" x 30" (60cm x 76cm)
	Green Gold	
	Hansa Yellow Light	
	Hansa Yellow Deep	Bar soap
	Oxide of Chromium	Masking fluid
	Payne's Gray	No. 2 pencil
	Permanent White gouache	Old bath towel
	Prussian Blue	Palette
	Quinacridone Pink	Scotch tape
	Winsor Violet	Soft-bristled toothbrush
		Soft rags or paper towels
	Brushes	Tracing paper
	Nos. 1, 2, 4, 6 and 12 rounds	Water-filled spray bottle
	Nos. 1, 2 and 4 synthetic rounds	Workable fixative
	1½-inch (38mm) hake or flat	

Tip
Working With Varied Light Sources

The photo references for *Spring Lilacs— Goldfinches* come from three different places with three different light sources. The problem is corrected by brightening the light on the flowers and the fence. When light comes from totally different directions you may have to alter the photographs. You can have the image reversed at your local photo processor. This will make an image that mirrors the original.

Reference Photographs for *Spring Lilacs—Goldfinches*

Preliminary Sketch

This composite sketch was completed using the reference photographs pictured. This composition has two centers of interest. The male goldfinch, with his brighter color is the primary focal point. His dominance is reinforced by his placement on the page.

1 Work out the composition on tracing
paper, and transfer the design to water-
color paper. Once the design is transferred,
spray the whole surface with workable
fixative to preserve the pencil lines. Use
the nos. 2 and 4 synthetic rounds to mask
the design as shown. Note that it is not
necessary to mask the entire fence.

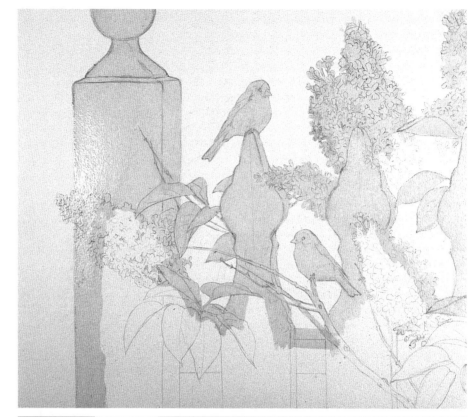

2 Place the paper with your completed
drawing on a large bath towel. Mix
large, cream-consistency puddles of Payne's
Gray, Oxide of Chromium and Winsor
Violet on your palette. Use the 1½-inch
(38mm) flat to wet the background, avoid-
ing the lower part of the fence. Load the flat
with a dark mix of gray and green and begin
at the upper right corner. Alternate the
gray-green mixture with a mixture of
Payne's Gray and Winsor Violet, concen-
trating the violet mix behind the flowers.
Here and there behind the masked flowers,
use the no. 12 round to paint some flower
shapes with Winsor Violet alone. Tilt the
paper to create soft blends. Dry with a hair
dryer and remove the mask.

Use the no. 12 round to paint the small
background areas behind the lower part of
the fence with the same colors, using the
wet-on-dry method.

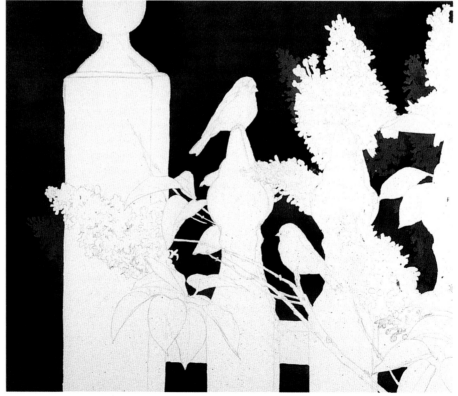

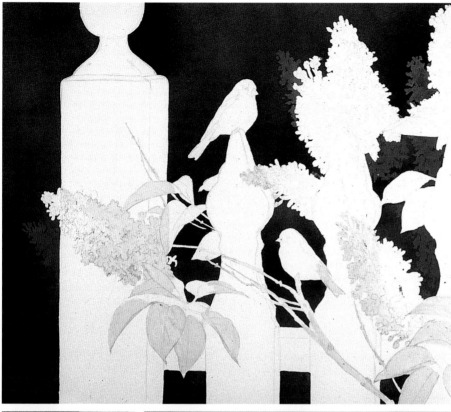

3 Use the nos. 2 and 4 synthetic rounds to mask the flowers, leaves and bird tail that overlap the fence.

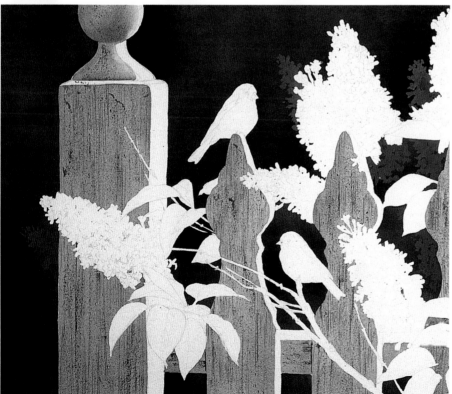

4 Mix puddles of Payne's Gray, Prussian Blue and Winsor Violet on your palette, adding more water to make pale tints. Use the no. 12 round to paint a mixture of these colors on the shadowed part of the fence, avoiding the sunlit sides. For the finial, indicate a rounded form by applying the color to the darker side and pulling out to the highlight. Paint darker-value shadows under the finial ball and under the flowers and leaves. Dry with a hair dryer.

Carefully cover the upper part of the painting and the female goldfinch with paper towels or paper scraps to make a protective screen, taping the edges in place to secure them. Load the no. 6 round with dark Payne's Gray and drybrush this over the shady areas of the fence. Load the toothbrush with the same color and spatter the area lightly. Mix a little Burnt Sienna into the gray and add a few details on the sunlit sides.

113

5 Carefully clean the palette and mix small puddles of Hansa Yellow Light, Hansa Yellow Deep and Payne's Gray. Using the no. 4 round, paint the head, mantle, side and belly of each goldfinch with Hansa Yellow Light, avoiding the male's crown and the wings and under-tails of both birds. Pull out to leave bright highlights on the male's head and breast and on the female's nape and mantle. Dry with a hair dryer.

Mix some Hansa Yellow Deep into the light yellow, and paint this on the deeper shadow areas of the male, especially the flank, ear patch and eye-line. Pull out to blend, conserving the highlights. Dry with a hair dryer.

For the male bird, paint hard-edged cast shadows with the yellow mixture across the breast and down the center, pulling out to blend. Dry with a hair dryer.

Add some Payne's Gray to the yellow mixture and apply this to the darkest shadow areas of both birds, pulling out to round the forms. Notice the dark value on the female's breast. Use the no. 1 round to paint the eyes of both birds with dark Payne's Gray, conserving highlights. Also paint the male's crown and the wings of both birds, leaving the wing-bars white and leaving a light highlight on the female's back. Shade the under-tails with diluted Payne's Gray and use the no. 1 round to add fine feather lines. Paint the beaks and feet with Burnt Sienna, pulling out to leave a bright highlight at the top edges. Shade and detail with a mixture of Payne's Gray and Burnt Sienna.

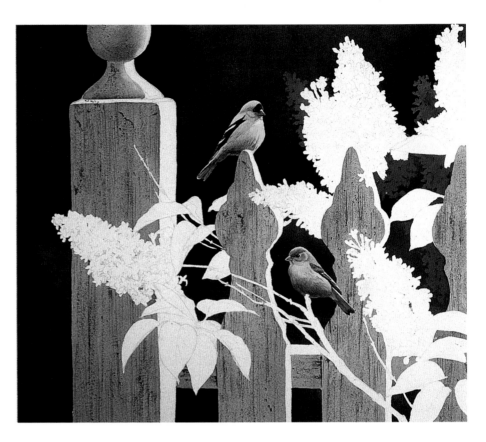

Tip

Negative Painting

Negative painting is the process of making a detail or an object stand out by painting a darker value behind it, thereby defining its edges with more contrast. It may be helpful to redraw parts of your composition with your pencil so you can tell where to add color.

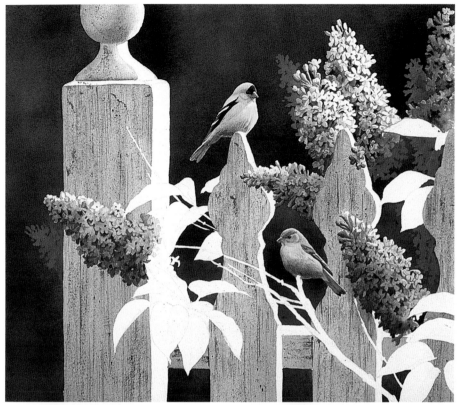

6 Mix puddles of Quinacridone Pink and Winsor Violet. Using the no. 4 round, apply the pink to the dark sides and middles of each lilac cluster, pulling out to leave the upper side bright. Dry with a hair dryer.

Repeat with Winsor Violet, leaving plenty of pink in the center areas of the cluster. Using the no. 2 round and violet, define some of the individual florets with negative painting and add a few details. Paint flower centers with Burnt Sienna. Mix a little Permanent White gouache into the violet and use the no. 2 round to paint a few floret shapes on the background lilacs. Add a few florets with a pink-white mix also.

Detail of Female Goldfinch

Detail of Male Goldfinch

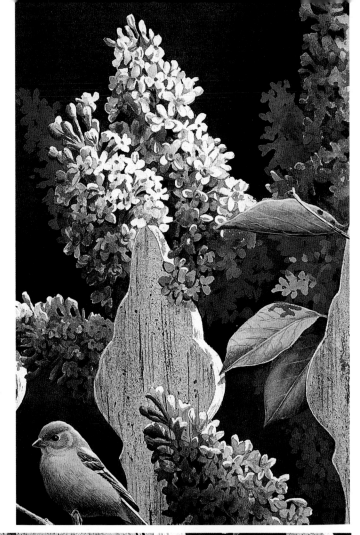

7 For the leaves, mix puddles of Oxide of Chromium, Payne's Gray and Green Gold. Use the nos. 2 and 4 rounds to paint the leaves with Green Gold, pulling out to create bright highlights on some leaves. Use the no. 1 synthetic round to mask the veins on a few of the leaves that will be dark. Build up the washes with a mix of Green Gold and Oxide of Chromium, charging with a chromium-gray mix in the darkest areas. Dry with a hair dryer.

Add the darker veins using the no. 1 round.

8 Paint the twigs with a mix of Payne's Gray and Burnt Sienna, drybrushing for texture and leaving light highlights on the sunlit twigs.

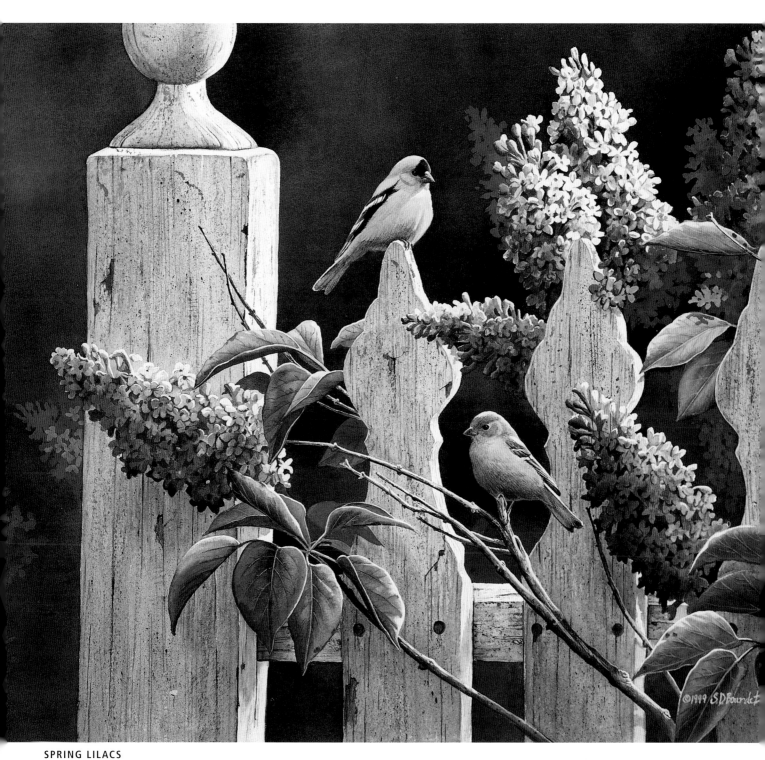

SPRING LILACS

American Goldfinches
Watercolor on Arches 300-lb. (640gsm) cold-pressed paper
16" x 12" (41cm x 31cm)

Vineyard Sentinel—Bluebird

This carefully tended vineyard is a fine example of how attractive farms and gardens can be to wildlife. The owners are bird lovers, and they've placed bluebird houses among the grapevines. Now, having created homes for several bluebird families, they can enjoy this sight all summer long and look forward to the return of the birds each spring! When I visited the vineyard, it had just rained. The fence post closest to me was entwined with vigorous new summer growth. The vines were backlit, so the leaves appeared to be a vibrant, translucent shade of chartreuse against the dark sky. In the distance, the male bluebird was searching for bugs to feed his hungry brood. When he landed for a moment on my post, his plumage contrasted so vividly with the leaves that I wanted to capture the effect in a painting.

MATERIALS LIST	
Watercolors	**Other**
Burnt Sienna	Arches 300-lb. (640gsm) cold-pressed paper, 30" x 12" (76cm x 31cm)
Cobalt Blue	
Naples Yellow	Bar soap
Organic Vermilion	Facial tissues
Oxide of Chromium	Hair dryer
Payne's Gray	Masking fluid
Permanent Red Deep	Masking fluid pick-up
Permanent White gouache	No. 2 pencil
	Palette
Prussian Blue	Soft rags or paper towels
Raw Sienna	Water-filled spray bottle
Raw Umber	Workable fixative
Brushes	
Nos. 1, 2 and 4 rounds	
2-inch (51mm) hake	
Old no. 2 synthetic round	

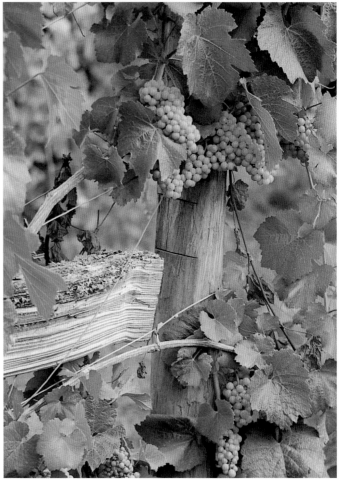

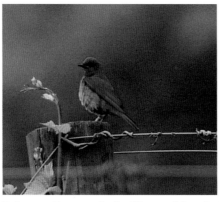

Reference Photographs for *Vineyard Sentinel—Bluebird*

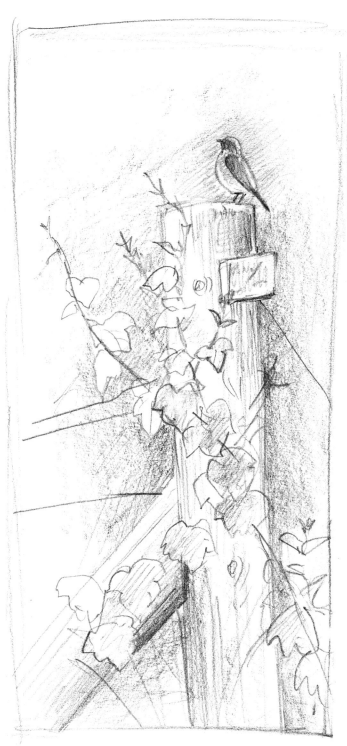

Sketch for _Vineyard Sentinel—Bluebird_
Compose your sketch using reference photographs.

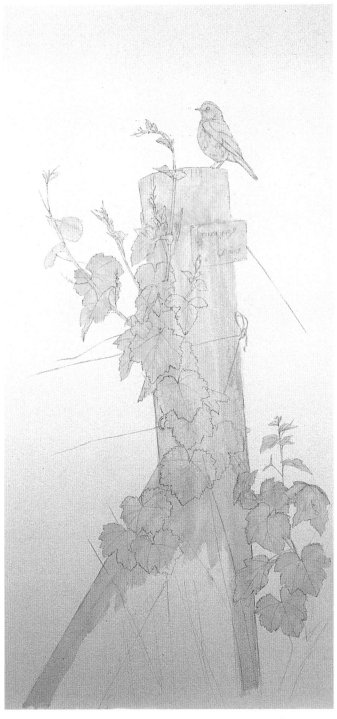

1 Transfer your image onto the watercolor paper, then mask the areas shown with the nos. 2 and 4 synthetic rounds. You don't have to mask the entire area at the bottom of the post, just the perimeter.

2 Using the back of your palette or a large white enameled tray, mix large, thick puddles of Payne's Gray and Oxide of Chromium, smaller puddles of Green Gold and Cobalt Blue. Take the 3-inch (76mm) hake and evenly wet the background area of the painting, avoiding the middle of the fence post. Mix some of the Payne's Gray with Oxide of Chromium, working the colors together to an even consistency to make a rich dark green. Beginning with the lower right side of the painting, crosshatch this color into the background, working up the right side, then behind the top of the post and over to the left side, leaving the upper left corner unpainted. Rinse and blot the brush, then load with Payne's Gray. Crosshatch this color into the background, blending with, but not covering the dark green. Use the 2-inch (51mm) hake to add some strokes of Green Gold here and there behind the leaves. Rinse the brush and clean the palette.

Mix Cobalt Blue and a little water into some Payne's Gray to make a light gray-blue. Stroke this color into the unpainted area at the upper left. If the paper is beginning to lose its shine in places, re-wet with the spray bottle, and then tilt the paper to create soft blends. Dry evenly with the hair dryer.

If your background has faded too much or appears blotchy, re-wet with the spray bottle and even out the colors, using the same colors and techniques as before, but diluting the colors a bit. Dry with a hair dryer until bone-dry. Remove the masking fluid.

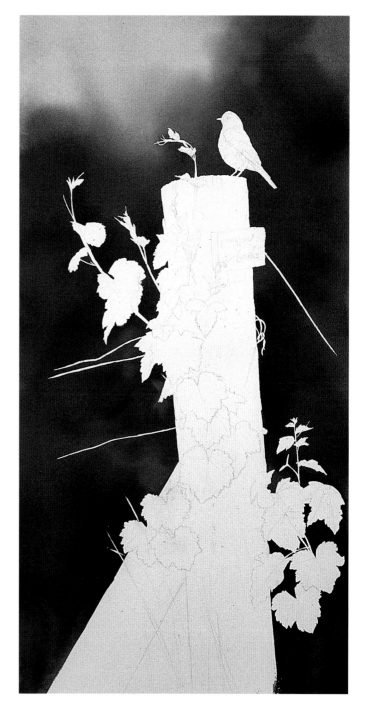

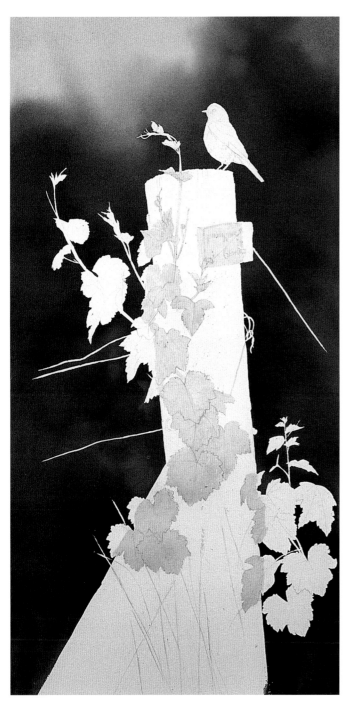

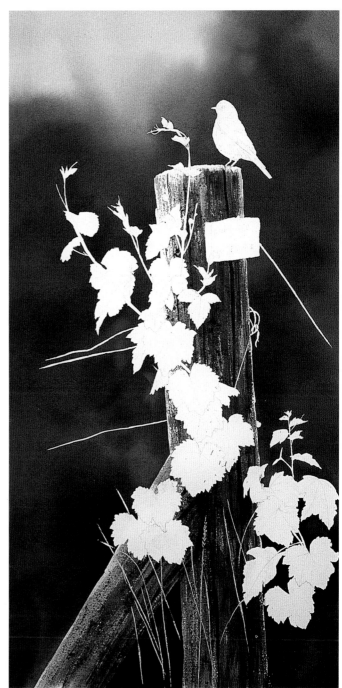

3 Use the no. 4 synthetic round to mask the leaves that overlap the fence post, the little decorative grape label and the grasses at the base of the fence.

4 On your clean palette, mix puddles of Burnt Sienna and Payne's Gray to make a rich dark brown. Rinse and blot the 2-inch (51mm) hake. Spread the bristles of the brush in a random line, then load well with the dark brown mixture and use a continuous vertical drybrush stroke to paint the wood grain. Leave the upper left side of the post, its top and the upper edge of the brace light. Repeat, alternating with the pure Burnt Sienna and a more grayed mix of brown until you have a believable wood-grain effect. Dry with a hair dryer.

Cover the background of the painting with paper towels, leaving only the wood exposed. Spatter with the no. 8 round, using the same color mixtures. Finally, use a very dark mix of the gray and brown to paint some cracks and knots in the wood. Remove the masking fluid.

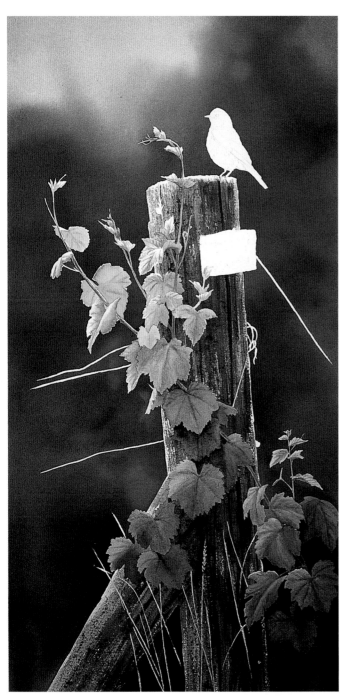

6 Use the no. 2 round to add some contrasting veins and details to the leaves. Use the no. 4 round to add deeper green shadows to the shaded leaves, using a mixture of Payne's Gray and Sap Green, and also to drybrush and paint some texture on the leaf surfaces here and there. Also add some touches of Quinacridone Gold and Burnt Sienna.

Use the no. 2 round to paint the grasses with Green Gold, Quinacridone Gold and Sap Green. Paint the wires and nails with Burnt Sienna, shading the underneath sides with a Burnt Sienna-Payne's Gray mix.

5 Using the no. 8 round, mix puddles of Green Gold, Oxide of Chromium and Sap Green on your clean palette. Use the nos. 2, 4 and 8 rounds as needed to paint the leaves, using Green Gold for the backlit leaves in the upper left and alternating with the darker greens for the leaves in the lower part of the design. For the stems and leaf tips, use Quinacridone Gold, conserving the white at the leaf tips and along the upper side of each stem.

7 Use the no. 2 round to paint the lettering on the wine label sign with Hansa Yellow Deep. Dry with a hair dryer.

Use the no. 2 synthetic round to mask over the painted letters. Dry with a hair dryer.

Use the no. 4 round to drybrush the front of the sign with Payne's Gray and Burnt Sienna, varying the colors as you did on the rest of the fence-post. Paint the edge, making the color a bit lighter, then add some darker brown cracks and strokes for wood grain. Save the brown mixtures. Remove the masking fluid.

Mix a little Permanent White gouache with some of the fence post browns to make a very light brown. Use the no. 4 round to drybrush this here and there on the post, to paint in some wood grain pattern and to enhance the light edges of cracks and knots.

8 Use the nos. 2 and 4 rounds to paint the bird with Ultramarine Blue, beginning with the darkest areas on the head and wing and pulling out to the highlight areas. Notice that the bird is backlit, so a delicate edge of white should be left along the back and belly. Add Cobalt Blue to the scapulars, primaries and secondaries, blending the colors to round the form. Shade under the feather groups with a dark mix of Payne's Gray and Ultramarine Blue. Paint the eye and beak with Payne's Gray, conserving highlights. For the belly, breast and flank, shade with Payne's Gray, adding feather details. Dry with the hair dryer, then apply a light wash of Quinacridone Sienna to the breast and flank over the gray details.

Use the no. 2 round to enhance the feather details and highlights with Permanent White gouache, being careful not to cover or dull the washes. Use fine strokes of Permanent White gouache to soften the highlight so the bird doesn't look cut out.

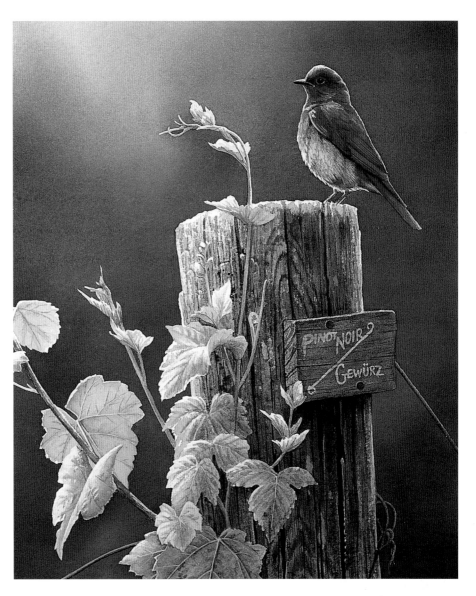

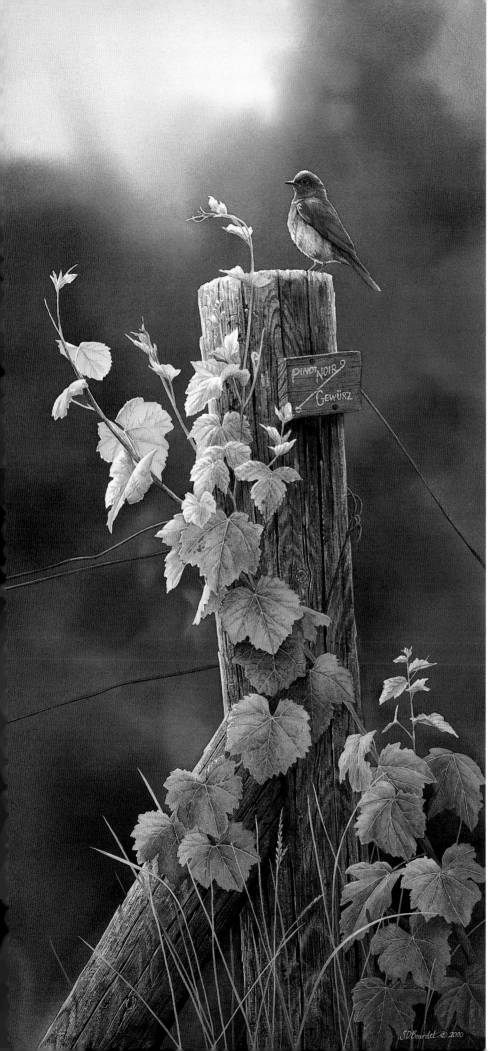

VINEYARD SENTINEL
Western Bluebird
Watercolor on Arches 300-lb. (640gsm) cold-pressed paper
37" x 17" (94cm x 43cm)

Autumn Splendor—Blue Jay

The idea for this piece came from one of my favorite hometown haunts, a stately old Victorian mansion built in the 1890s. In its day, the estate was surrounded by many forested acres and beautiful perennial gardens. Since then, it has changed hands countless times and suffered from the ravages of time and neglect. One autumn morning after a rainstorm, I passed the weary old lattice fence behind the mansion and saw it gracefully draped with colorful maple leaves. Before I was even out of the car with my camera, I knew I'd paint this scene. (Over the years, I've learned to take the camera with me—even on trips to the grocery store—because ideas can pop up at anytime, anyplace.) In planning the painting, the setting came to me before I had any idea to paint the blue jay. At home, I consulted my file of songbird photos and came up with this pose. It is ideal for the fence post because the beautiful pattern of the jay's back feathers are displayed while it looks toward the center of the painting. The rich blue of the plumage is complementary to the red-orange of the leaves. Notice that all of the colors vary so that analogous hues are incorporated, making the complementary theme more complex.

Reference Photographs for *Autumn Splendor—Blue Jay*

MATERIALS LIST	**Watercolors**	**Other**
	Burnt Sienna	Arches 300-lb. (640gsm) cold-pressed paper,
	Cobalt Blue	23" x 18" (58cm x 46cm)
	Hansa Yellow Deep	
	Hooker's Green Dark	Bar soap
	Naples Yellow	Facial tissues
	Organic Vermilion	Hair dryer
	Oxide of Chromium	Masking fluid
	Payne's Gray	No. 2 pencil
	Permanent White gouache	Old bath towel
	Raw Umber	Palette
	Ultramarine Turquoise	Soft rags or paper towels
		Water-filled spray bottle
	Brushes	Workable fixative
	Nos. 1, 2, 3 and 6 rounds	
	Old nos. 1 and 3 synthetic rounds	
	2-inch (51mm) hake	

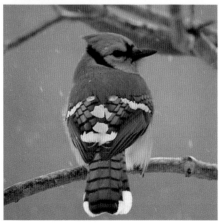

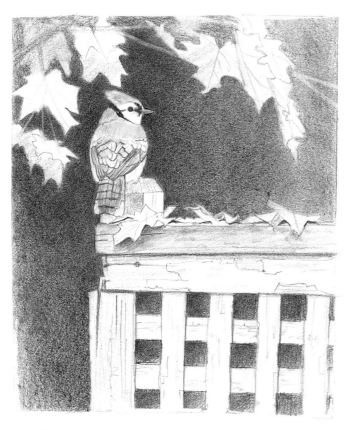

Sketch

Sketch your image using your reference photographs.

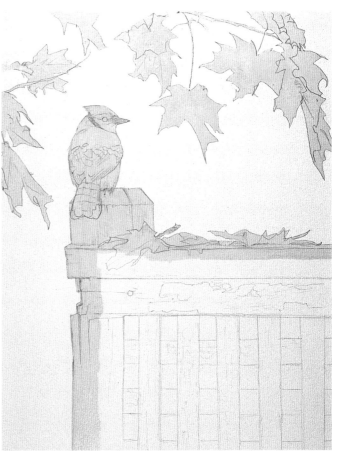

1 Draw your composition on your water-color paper and spray the entire surface lightly with workable fixative. Use masking fluid and a soaped no. 3 synthetic round to mask the leaves and twigs, the blue jay and the outer perimeters of the fence along the top and left-hand side. For areas too small for the no. 3, use a no. 1 round.

2 Mix two large puddles of color—one of Payne's Gray and one of Oxide of Chromium. The puddles should be thick enough so that a brush pulled through will make a valley that doesn't run right back together. Use your 2-inch (51mm) hake to coat the background area of the painting evenly with clear water. Do not wet behind the lattice. Dry under the edges of your painting with a clean rag and place it on a bath towel. With a wet but not drippy 2-inch (51mm) hake, pick up a brushload of Payne's Gray. Use the crosshatch stroke to lay the color in, starting with the area behind the blue jay. Mix some Oxide of Chromium with Payne's Gray, use the crosshatch stroke and work toward the right side of the painting. Alternate between the two colors, making some areas greener to designate background foliage and work in some Burnt Sienna behind the leaves and at the lower left corner. Continue in this manner over the entire background. Dry the painting, being careful to move the hair dryer over the whole surface so it dries evenly.

If the dry background has faded so that the contrast is not rich enough or if the colors look blotchy and uneven, you will need to apply a second coat. Use your spray bottle to re-wet the background area. Using the 2-inch (51mm) hake add more of the same background colors to any areas that look faded or uneven. Dry with a hair dryer. Peel off the mask.

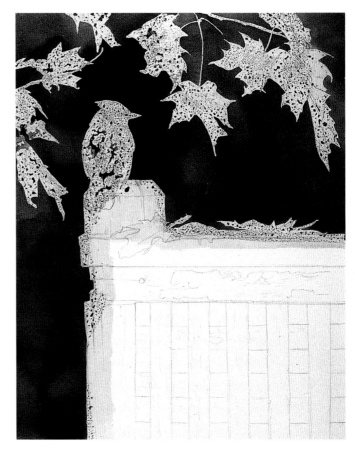

Tip
Don't Add Too Much Water

Be careful that your brush is not overloaded with water when you add color, or you will disturb the even balance of wetness on the paper. You should maintain a nice, shiny surface with no puddles or runny areas. Extra water can be picked up with a damp brush.

Tip
Using the Hair Dryer

Before drying, use a small soft rag or tissue to blot the wet paint off the masked areas. The force of the hair dryer can push the drips into the wash and mar the background!

3 Re-draw each leaf with your pencil to define highlights. Use your no. 1 synthetic round to mask the veins. Mix small puddles of Organic Vermilion, Burnt Sienna, Hansa Yellow Deep and Naples Yellow. Use your no. 3 round and a mix of vermilion and sienna to paint the darker areas of the orange leaves, pulling the color out to the lightest values. Make some leaves more vermilion and others more sienna and add touches of yellow here and there. Repeat this method for the golden leaves, using Hansa Yellow Deep and Naples Yellow as the base colors and working in touches of vermilion and sienna. Work on one leaf at a time, building up the glazes. When dry, remove the mask and glaze gently over each leaf with a thin wash of Hansa Yellow Deep to tint the veins. Use the no. 1 round and your mixture of vermilion and sienna to paint the stems, then mix Payne's Gray with Raw Umber for the twigs. To give each twig a round shape, apply the concentrated color to the lower side and then pull the color up. Also paint in a few leaf scars and knots.

Be sure to keep the highlight at the top of the crest.

Be sure to conserve the white wing- and tail-tips and the very edges of the primary feathers.

Darkest values will be along the left side since the light comes from the right.

Each feather should be painted, then dried, so you can shade it carefully.

Fine lines of diluted Payne's Gray give the effect of delicate white feathers.

4 Mask the bird's wing-tips using the no. 1 synthetic. Use the no. 3 round to mix puddles of Cobalt Blue and Ultramarine Turquoise. With a mix favoring the cobalt, paint the darkest areas on the bird's forehead, pulling out to the lightest value at the crown. Repeat from the top of the crest, again pulling out to the crown. Paint the cheek patch, neck and mantle in the same manner. Dry. Add feather texture to the face with fine lines of diluted turquoise. Use your no. 1 round to paint the stripes on the head with concentrated Payne's Gray. Make the edges of these stripes ragged by pulling fine strokes of color into the white areas. Use the no. 1 round to paint a dark ring of Payne's Gray around the inner rim of the eyelid. Rinse the brush and pull the color toward the center of the eye, leaving a white highlight. Add a little Burnt Sienna near the center of the eye for a warm reflection. Along the lower outside rim of the eyelid, paint tiny dots of diluted Payne's Gray, leaving a narrow unpainted band between these dots and the eye itself. Use the same color to detail the feathers around the eye. For the beak, apply a more concentrated mix of Payne's Gray to the lower mandible, pulling the color toward the upper edge. Use fine lines of Payne's Gray to designate the nostril and mouth-line.

5 Re-draw the feathers on the back and tail of the blue jay, paying particular attention to how the feathers overlap and are tipped with white. Be sure to conserve these whites. Mix small pools of Ultramarine Turquoise, Cobalt Blue and Payne's Gray. Use your no. 2 round to paint the feathers of the wing coverts and secondary group one feather at a time with Ultramarine Turquoise, shading with Cobalt Blue where they overlap. Use the same process for the feathers of the tail, except grade each feather to black at the tail tip. Dry before continuing to the next feather.

When all the wing and tail feathers have been painted, add the dark bands with Payne's Gray. The primaries should be painted with Cobalt Blue, tinted a little with Payne's Gray, and then shaded with darker Payne's Gray. When all of the feathers are dry, use your no. 1 round to paint a few fine diagonal lines to indicate the barbs. Also use your no. 1 round and some diluted Payne's Gray to paint fine, fluffy feathers on the white sides of the jay, adding a shadow under the wing. For ease in painting and drybrushing the fence finial, use the no. 1 synthetic round to mask the hind toe of the blue jay and the flank feathers that overlap onto the wood.

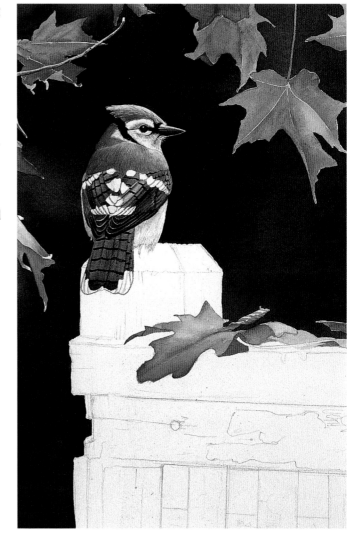

Tip
Dry Those Washes
Remember that washes must be bone-dry before you can glaze over them and be careful to preserve the light highlights so that the leaf has a three-dimensional form.

Tip
Color Mixing Simplified
In painting the fence, you will be alternating between several colors. When you mix these colors on your palette at the beginning of step 7, mix good-sized puddles of the ones you will repeat most often. This will save you the time and trouble of re-mixing each time you start a new area. Colors you will need to mix in larger quantities are the Permanent White-Hooker's Green Dark and the Payne's Gray-Raw Umber.

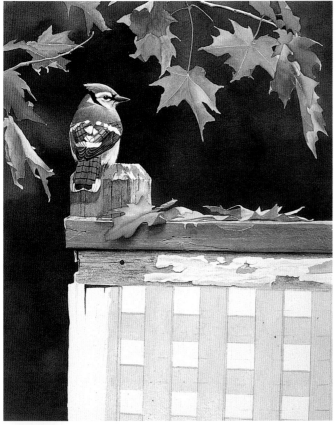

6 Use the no. 3 synthetic round to mask the leaf that overlaps onto the top rail and the lattice work below. Mix a little Permanent White gouache with a bit of Hooker's Green Dark. Use the no. 6 round to paint this mixture on the front side of the top rail, avoiding the upper edge of the rail and the patches where the paint has chipped off. Drybrush this green color here and there on the sides of the final post. Mix a little Payne's Gray with some Raw Umber to make a warm yellow-gray. Drybrush patches on the slanted portions and the sides of the final post. Fill in the chipped paint spots. Use Payne's Gray mixed with Hooker's Green and Raw Umber to paint the shadows under the jay's tail and under the leaves on the fence. Lightly drybrush over the top rail and final to add texture. Very lightly drybrush the thinned Hooker's Green-white mix on the top edge of the rail, avoiding the leaves. Use your no. 1 round and concentrated Payne's Gray to paint the jay's hind toe, to lightly outline the top rim of each chipped paint spot, and to add some cracks and splits in the wood. Use your no. 3 round to paint a dark shadow under the green rail, pulling the color out on both edges to soften the shadow. Use the no. 3 synthetic round to mask the slats of the lattice and the edges of the horizontal and vertical supports.

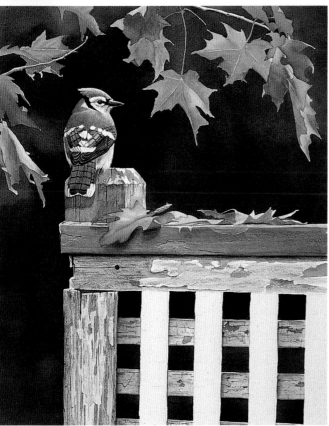

7 Make a rich mixture of Payne's Gray and Oxide of Chromium. Also mix up a small amount of Burnt Sienna. Without wetting the background behind the lattice, use your 2-inch (51mm) hake to fill in all of the squares of the background, varying the color so that the dark green shade is at the top of the fence and the sienna color shows through the lattice at the bottom. Dry thoroughly with the hair dryer, blot the excess paint from the masked areas and then peel off the mask.

Use the Payne's Gray and Raw Umber mixture you made for step 6 to paint a thin wash over the horizontal slats and the vertical post with the no. 6 round. Dry with a hair dryer.

Drybrush back and forth over the horizontal slats and up and down on the vertical post with a darker mix of the same color made by adding a little more Payne's Gray. Also use this darker color to paint the patches on the vertical post where raw wood shows. Randomly paint some patches of the Hooker's Green-Permanent White mixture. Paint the head of the nail with Burnt Sienna and pull a little of the color down to create a rust stain. Finally, drybrush a mixture of Hansa Yellow Deep and a little Hooker's Green Dark over the exposed wood areas of the fence to make them look mossy.

8 With your no. 3 round, use a mixture of Raw Umber and
Payne's Gray to paint the chipped areas on the vertical slats
where raw wood shows. Lightly drybrush up and down over all the
verticals with this same color. Use a more concentrated mix of this
color and the no. 1 round to paint fine lines into the chipped areas
all over the fence to simulate wood grain. Be sure to keep the
vertical slats lighter than the horizontal ones. Add some shadows of
Payne's Gray mixed with a little Cobalt Blue to the horizontal slats
where they meet the verticals, pulling the color out to a lighter blue
at the center of each little square. These cooler shadows will help to
push the horizontal slats back into the picture plane. Use the no. 1
round to add a few cracks and paint some shadows under the edges
of the chipped white paint with concentrated Payne's Gray. Use the
no. 3 round to soften all of the shadows by pulling out.

9 At this point, the painting is nearly finished. Set it at a distance
and make sure the values look consistent. You can now make
some corrections and add details to the foreground components. If
some areas appear too light, re-mix those colors and glaze over your
previous washes to make the color richer. Take your no. 1 round
and add some surface details where needed. Use a little concentrat-
ed Burnt Sienna to add some darker color around the leaf veins.
Add some spots on the leaves for a touch of realism and drybrush
some of the leaf surfaces for added texture. This is a fairly uncompli-
cated composition, but it is easy to see how vibrant contrasts, good
values and attention to detail can combine to make a striking
result. This painting would be uninteresting without the richness of
the dark background. Good painting decisions are not usually a
matter of filling the picture with objects and details but are often
found in strong, simple concepts.

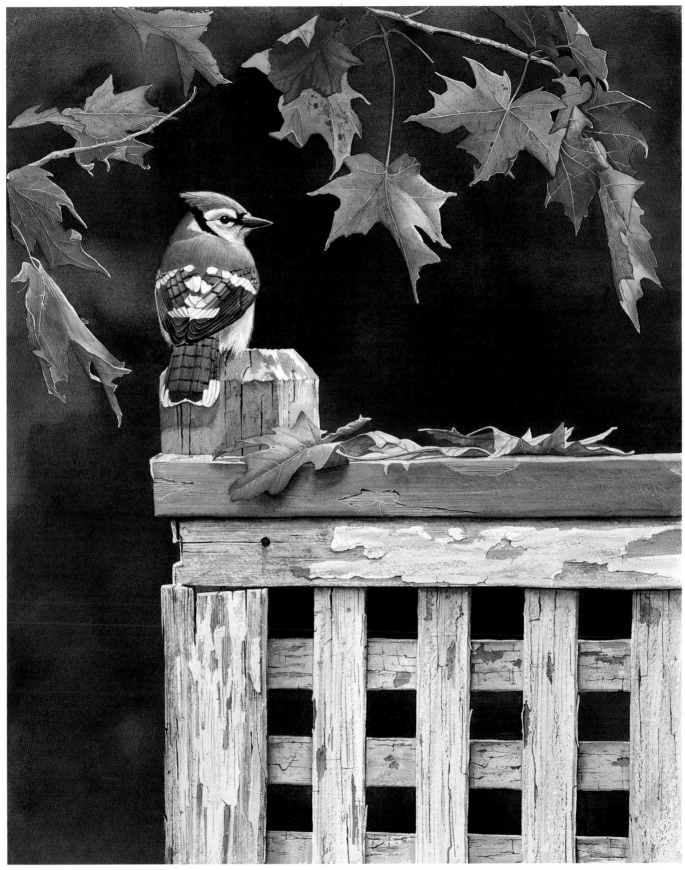

AUTUMN SPLENDOR

Blue Jay

Watercolor on Arches 300-lb. (640gsm) cold-pressed paper

22" x 17" (56cm x 43cm)

Winter Perch—Northern Cardinals

A thick blanket of snow simplifies nature in all her complex colors and textures, transforming every shape and changing the entire palette we use. For this reason, forays into the winter landscape with your camera will enrich your paintings immeasurably. Even if the conditions don't allow the best photos, your observations will strengthen your understanding of the subject. Notice, for instance, that the value range on an overcast or snowy winter day is much narrower than it is in the summertime. In these winter conditions, you could compose an entire painting of values in the medium range. On the other hand, bright light does the opposite—because you have the dazzling whiteness of all that snow and reflected light, you will notice that the dark values appear to be very dark, like the black-green of evergreens.

The weather conditions had to be just right to create the fluffy, lightweight snow in this painting. This kind of subject appeals to me because I have always felt that the essence of winter is the absolute quiet of a new snowfall. I photographed it in my parents' backyard in western Montana. Every pine needle and twig had its own blanket of delicate crystals, and they lasted only until the sun's first rays hit the tree. I had to work fast, shooting a whole roll of film, before the magic dissolved.

I decided that the snow effect would be best set off with high contrast, so I chose to do a dark background and opted for a punch of strong color—the cardinals. Careful use of masking fluid creates the lacy edge.

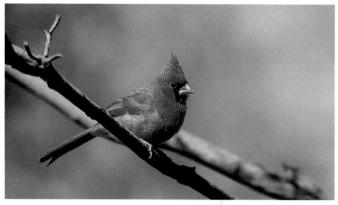

Reference Photographs for *Winter Perch—Northern Cardinals*

MATERIALS LIST	Watercolors	Other
	Burnt Sienna	Arches 300-lb. (640gsm) cold-pressed paper, 30" x 12" (76cm x 31cm)
	Cobalt Blue	
	Naples Yellow	
	Organic Vermilion	Bar soap
	Oxide of Chromium	Facial tissues
	Payne's Gray	Hair dryer
	Permanent Red Deep	Masking fluid
	Permanent White gouache	Masking fluid pick-up
		No. 2 pencil
	Prussian Blue	Old bath towel
	Raw Sienna	Palette
	Raw Umber	Soft rags or paper towels
		Water-filled spray bottle
	Brushes	Workable fixative
	Nos. 1, 2 and 4 rounds	
	2-inch (51mm) hake	
	Old no. 2 synthetic round	

Sketch
Create a sketch using reference photographs.

1 Carefully draw the composition on your paper, taking the time to draw in each snow-covered needle so that you will have a clear understanding of where color should be applied. Spray the entire piece lightly with workable fixative. Apply masking fluid with a soaped no. 2 synthetic round to all areas adjacent to the dark background. You should mask both birds and the edges of all pine branches on the left, leaving the interior branches on the right unmasked. Be sure to do the ends of the needles carefully to create a ragged, lacy edge.

2 Mix large puddles of Payne's Gray, Oxide of Chromium and Cobalt Blue on your clean palette, making the puddles about the consistency of thick cream. Place your paper on an old bath towel and evenly wet the background with your 2-inch (51mm) hake. Mix a little of the chromium and cobalt into the Payne's Gray to make a very dark mixture. Start with the areas closest to the pine, working the dark color into the negative spaces and then brushing out toward the left side of the composition. Dilute the color a bit and add more cobalt and chromium to the mix, then apply to the left edge. While the paint is still shiny-wet, use your spray bottle to lightly spritz the color and tilt the paper to create soft blends. Blot off excess paint from the masked areas and pick up any puddles of color with your brush. Dry with the hair dryer.

Apply a second coat to the background if needed, but remember that the surface must be bone-dry before you begin. When the painting is totally dry, peel off the mask. For the smaller areas, it might be helpful to use a masking fluid pickup. Be careful to rub gently so that the background isn't scarred.

3 Here's where your careful drawing will pay off. Use your nos. 2 and 4 rounds to paint a mix of Cobalt Blue and Payne's Gray in the negative spaces around and under the snowy needles. It works best to start by defining the lightest, most super-ficial needles by leaving the white shapes and painting the shadows under them, then working down to the next layer with a medium blue shade, and finishing with the deepest layer of needles, which will be the deepest blue. You will need to use your hair dryer as you go so the wet areas don't run together. Apply a light glaze of Prussian Blue over some of the most shadowy areas of the snow to vary the blues. When all areas are dry, use your no. 1 round with a little Oxide of Chromium to paint the pine needles in the snowy shapes.

4 Mix a little Burnt Sienna with a little Raw Umber to make a rich brown. Use the no. 2 round to paint the lower scales of each pinecone, leaving some white patches for snow. For the upper scales that have more light on them, use Raw Sienna. Dry with the hair dryer and apply a light wash of Cobalt Blue to the snow in the pinecones where they are in the shade. Use the mix-ture of Raw Umber and Burnt Sienna to paint the exposed twigs. Shade under the scales of the pinecones and the undersides of the twigs with a mixture of Raw Umber and Payne's Gray.

5 For the male cardinal, mix small puddles of Permanent Red Deep, Organic Vermilion, Payne's Gray and Naples Yellow on your clean palette. Use your no. 2 round to paint the primary and secondary feathers, the forehead and crest, the ear patch and the chest of the bird with the dark red. Concentrate the color on the right, pulling out toward the left, so that bright highlights are left along the crown, back and top of the tail. Mix a little vermilion with the dark red to make a lighter wash and apply this to the side, flank and upper-tail coverts, leaving some white feathers at the edges of the wing. Mix a little Payne's Gray with Permanent Red Deep for the shadow areas on the underside of the tail, belly and chest. Adding more Payne's Gray to the mix, use your no. 1 round to define the wing feathers and the shadow line under the wing. Use the no. 1 round to paint the dark face patch and the eye with Payne's Gray, leaving a delicate white ring for the eyelid and a tiny white highlight in the eye. Paint the legs and beak with Naples Yellow, shading and detailing these areas with vermilion and Raw Umber. Refer to chapter 5 to help you finish the details.

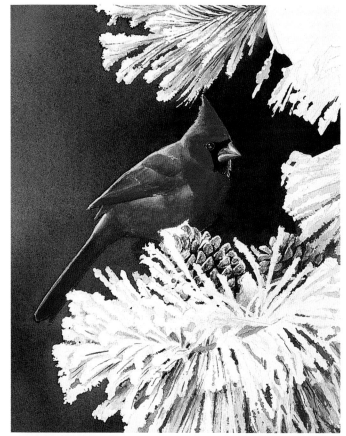

6 You can see that in this step there is one more pinecone than in the earlier steps—I decided that the design would be more interesting if I added another pinecone. I drew the additional pinecone on a piece of paper and placed it on just the right spot of my painting. This method allows you to see exactly how a new element will affect the painting. When you are sure where to place the pinecone, use the same process from step 4 to paint it on your watercolor paper.

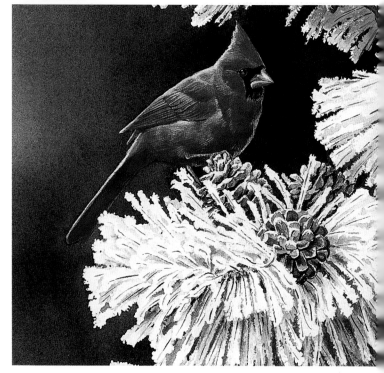

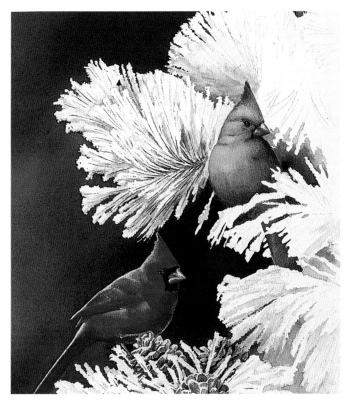

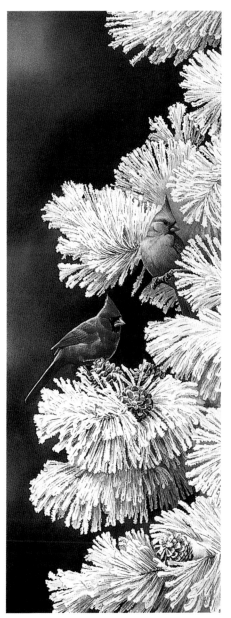

7 On your clean palette, prepare small puddles of Naples Yellow, Raw Umber, Raw Sienna, Permanent Red Deep, Vermilion and Payne's Gray. Use the no. 2 round to apply a mixture of Raw Umber and Raw Sienna, tinted with Vermilion, to the right side of the female bird's breast and to the belly, pulling out toward the chest. Use the same mix for the ear patch, forehead and crown, pulling out to leave highlights at the left of the ear patch and along the eyebrow line. Paint the lighter areas of the head and breast with Naples Yellow, leaving some white highlights to define feather groups. Use Raw Umber for the wing, adding Vermilion to the greater wing coverts. Shade the eye-line and under the ear patch, and define the feather groups with Raw Umber. Mix a little Payne's Gray into the Raw Umber and paint the under-tail coverts and the under side of the tail. Shade the belly and detail the wing coverts and the dark feathers on the face. Also use this mixture to paint the perch, carefully working the dark value around the toes. Paint the eye with Payne's Gray, leaving a small white highlight. For the beak and feet, apply a coat of Naples Yellow, then shade the beak with Vermilion and the feet with Raw Umber.

8 Now assess the values in your painting. Deepen the blues in the shadow areas if need be, and also use your no. 1 round to do a little negative painting, defining the crystalline edges of the snowy pine needles. You can use a little of your original background color to subtract tiny amounts of white at the edges of the branches, adding to the lacy-edged effect.

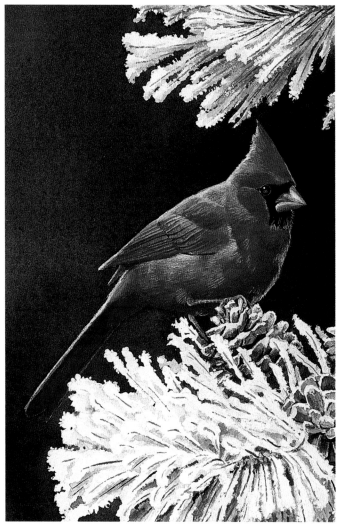

9 To finish the birds, you will need to add some feather texture. For the male, paint in some delicate strokes of Permanent Red Deep mixed with Payne's Gray on the breast and flank, crest and ear patch. Because the Permanent Red Deep is not a staining color, you can use a damp brush to lift off color where you need a little more highlight. Remember that highlight and shadows define the areas where feather groups overlap. As a final touch, mix a little Permanent White gouache with a bit of water. Use your no. 1 round to carefully add a few strokes of white along the back and crown. Where needed, define the edges of the secondary wing feathers and the greater wing coverts. Mix a little Cobalt Blue into the gouache and add a few feathers to the right edge of the belly to denote reflected light from the snow. Be sure to keep all of these strokes very delicate and feathery so as not to detract from the watercolor.

10 The female is completed in the same manner as the male. Define her feathers with fine lines of Raw Sienna on the breast and flank, crest and ear patch. Use your Permanent White gouache-water mix to carefully add a few strokes of white along the back and crown with the no. 1 round. Again, keep all of these strokes very delicate and feathery.

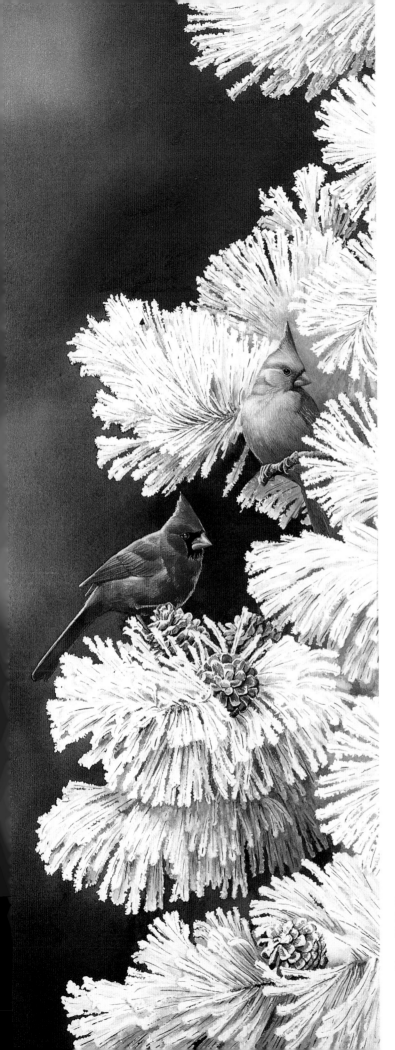

WINTER PERCH
Northern Cardinals
Watercolor on Arches 300-lb. (640gsm)
 cold-pressed paper
29" x 12" (74cm x 31cm)

Index

Capture the Magic of Watercolor With North Light Books!

This extraordinary reference provides a wealth of gorgeous, crisp photos that you'll refer to for years to come. Finding the right image is easy—each bird is shown from a variety of perspectives, revealing their unique forms and characteristics, including wing, feather, claw and beak details. Four painting demos illustrate how to use these photos to create your own compositions.

1-58180-452-0, paperback, 144 pages

Stop wasting hours searching through books and magazines for good floral reference photos. This wonderful reference puts more than 500 right at your fingertips! There are 49 flowers in all, arranged alphabetically, from Amaryllis to Zinnia. Each is showcased in multiple shots from different angles, including side views and close-ups of petals, leaves and other details.

0-89134-811-5, hardcover, 144 pages

Inside this incredible reference you'll find more than 1,000 definitions and descriptions—every art term, technique and material used by the practicing artist. Packed with hundreds of photos, paintings, mini-demos, black & white diagrams and drawings, it's the most comprehensive and visually explicit artist's reference available.

1-58180-023-1, paperback, 512 pages

This book gives you the confidence and skill you need to make the most of every second you spend painting. You'll learn a variety of timesaving techniques, create simple paintings in sixty minutes, then attack more complex images, breaking them down into a series of "bite-sized" one-hour sessions. Includes twelve step-by-step demos!

1-58180-035-5, paperback, 128 pages

Claudia Nice introduces you to the joys of keeping a sketchbook journal, along with advice and encouragement for keeping your own. Exactly what goes in your journal is up to you. Sketch quickly or paint with care. Write about what you see. The choice is yours—and the memories you'll preserve will last a lifetime.

1-58180-044-4, hardcover, 128 pages